W9-BNZ-578

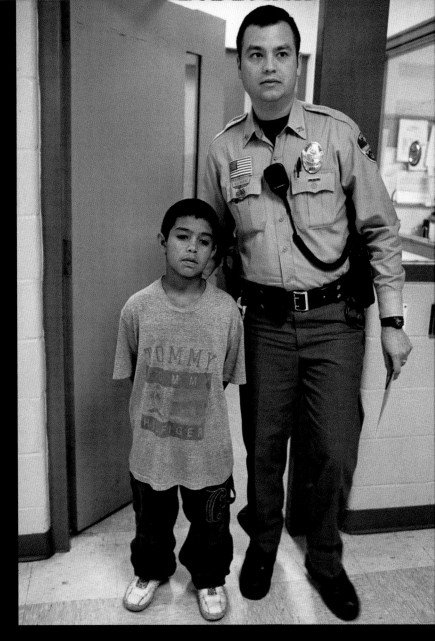

NO PLACE FOR CHILDREN

BILL AND ALICE WRIGHT PHOTOGRAPHY SERIES

No Place for Children

VOICES FROM JUVENILE DETENTION

BY STEVE LISS
FOREWORD BY MARIAN WRIGHT EDELMAN
INTRODUCTION BY CECILIA BALLÍ

University of Texas Press ⌄ Austin

Publication of this work was made possible in part by support from Bill and Alice Wright, the National Endowment for the Humanities, the Annie E. Casey Foundation, the John D. and Catherine T. MacArthur Foundation, the Open Society Institute, Myron Miller and his family, and Anne Stilwell Strong.

Designed by Ellen McKie

Requests for permission to reproduce material from this work should be sent to Permissions, University of Texas Press, Box 7819, Austin, TX 78713-7819.

∞ The paper used in this book meets the minimum requirements of ANSI/NISO Z39.48-1992 (R1997) (Permanence of Paper).

LIBRARY OF CONGRESS CATALOGING-IN-PUBLICATION DATA
Liss, Steve, 1954–
No place for children : voices from juvenile detention / by Steve Liss ; foreword by Marian Wright Edelman.— 1st ed.
 p. cm. — (Bill and Alice Wright photography series)
ISBN 0-292-70196-9 (cloth : alk. paper)
1. Juvenile detention—Texas—Laredo—Photographs. 2. Juvenile detention homes—Texas—Laredo—Photographs. 3. Juvenile corrections—Texas—Laredo—Photographs. I. Title. II. Series.
HV9106.L375L57 2005
365'.42'09764462—dc22 2004020594

This book is dedicated to the memory of my parents,

HELEN AND FRED LISS.

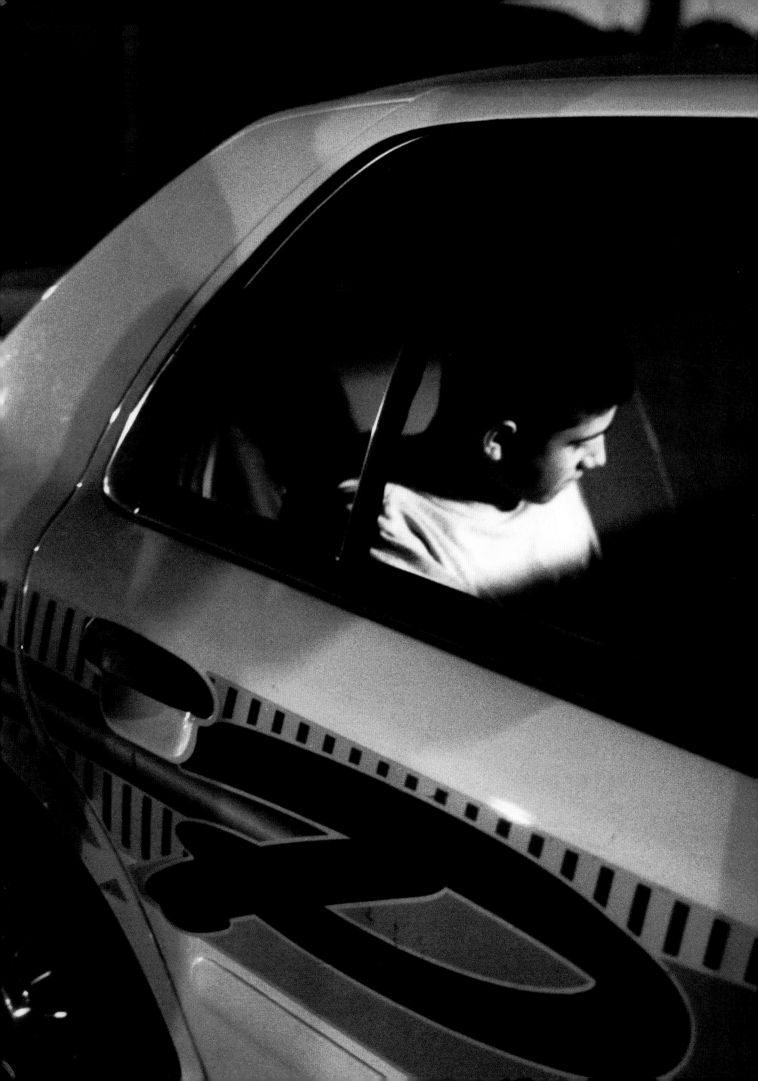

CONTENTS

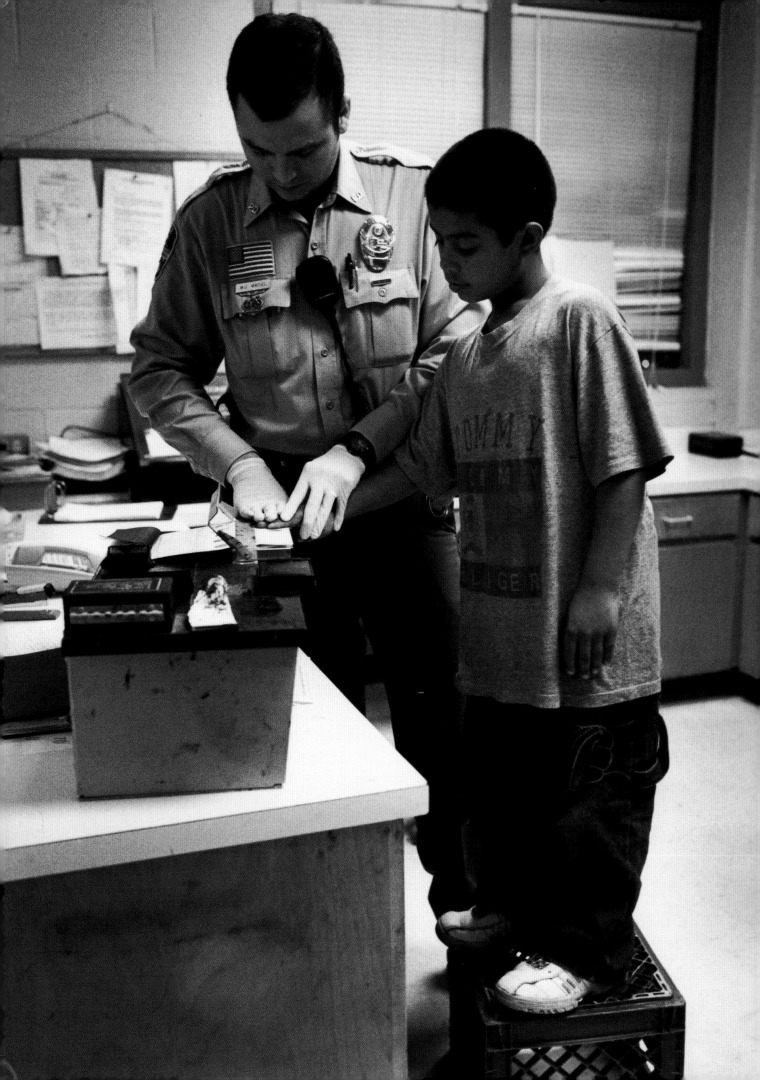

MARIAN WRIGHT EDELMAN

FOREWORD

We rarely see locked-up children because the laws established to protect their privacy have also kept them shut away from view. Fortunately, photographer Steve Liss gained unprecedented access to this hidden world and brings us face to face with some of the young people we are locking away by the multitudes—104,413 in public and private facilities on any given day in 2001 alone. His powerful photographs present a moving testimony to the humanity of some of America's most deeply troubled and misunderstood youth. And his poignant first-person interviews with children, parents, and

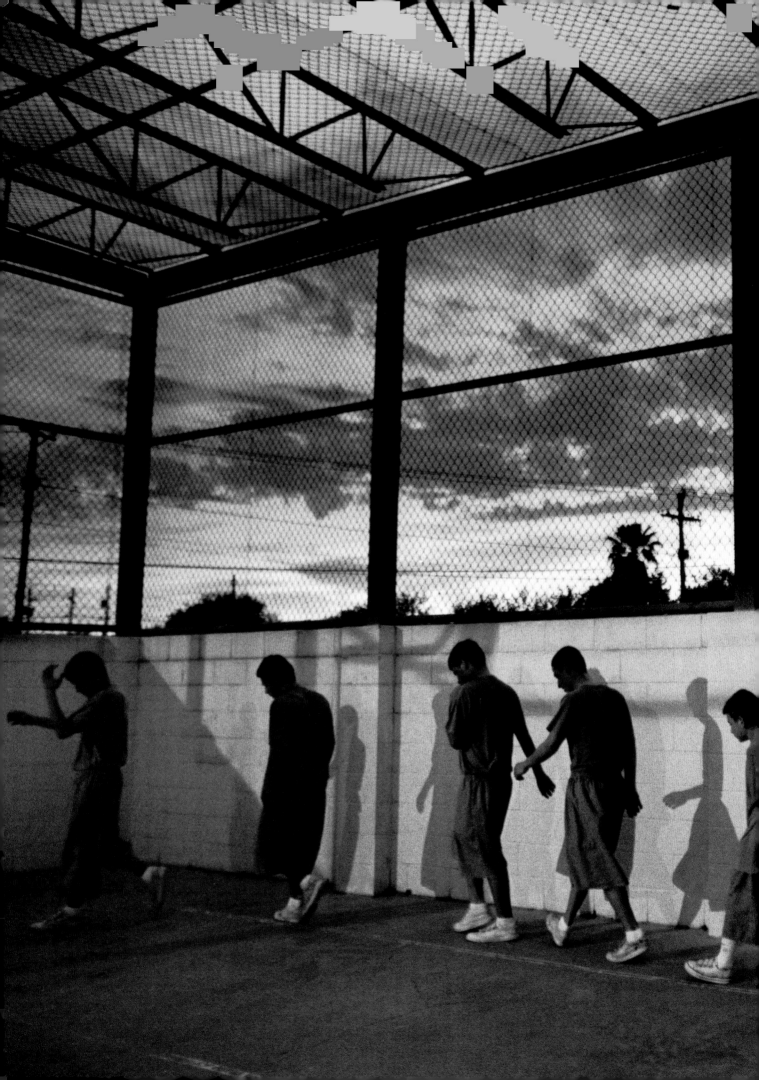

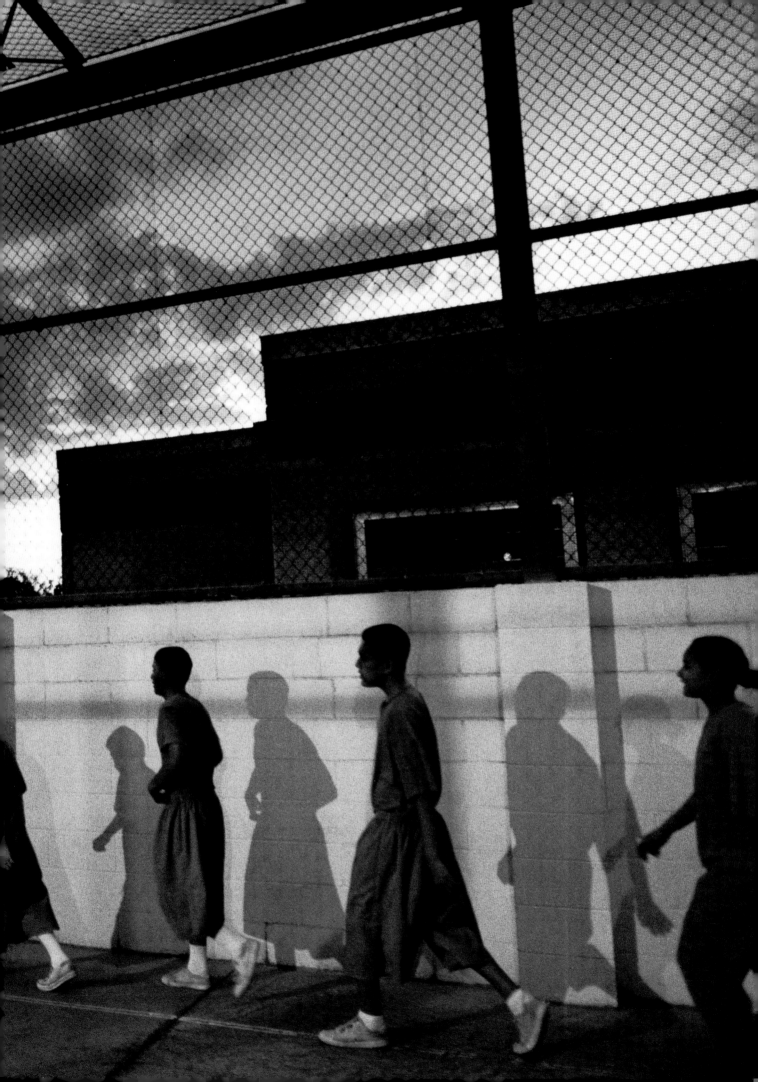

probation officers shatter the myths that these children are ruthless predators and that incarceration works.

Many of the children in this important book were raised with little or terrible parental guidance, have difficulty in school, and have emotional, mental, learning, or substance abuse problems. Few received the individual attention and extra help like tutoring or counseling that parents with resources use to guide their children into productive adulthood. Their trajectories are leading not toward college or gainful employment but to adult prison.

Tragically, as a nation, we are giving up on children like these. The state of Texas, where Liss took these photographs, spent $42,000 to incarcerate a juvenile in 2003. There, as elsewhere, more juvenile jails have been built, while programs that help families and children—which might keep at-risk youth out of the pipeline to prison—are cut back. Across America, few alternatives to incarceration exist, and many detention facilities have become dumping grounds for children who have been failed by the overburdened mental health and child welfare systems. Liss makes clear that most of the staff at the detention facility where he photographed do their best to provide services, but juvenile detention centers like this were never designed to meet the treatment needs of young people with mental health and substance abuse problems.

It is worth noting that only about one-quarter of incarcerated juveniles nationwide committed a violent offense, children of color are greatly overrepresented, and the numbers jailed have increased while the juvenile arrest rate has declined.

"Get tough" politicians insist that young people in trouble need to be incarcerated to "learn their lesson" or "take responsibility." Taking punishment, though, is not the same as taking responsibility. Incarceration is by definition a regimented world where decisions are made for you, schooling is disrupted, and your peers are other troubled youth. Rather than putting young people back on track, time in the Little House often leads to a future in the "Big House."

As a detention worker sadly explained to Liss, "How many success stories have there been where I can say we really were able to make a difference? I could probably just count them on the fingers of my right hand. You watch some beautiful lives just get wasted. . . ."

It's time for America to get its values straight and to invest in its children before they get into trouble or drop out of school. What sort of backward investment policy allows states to spend three times more per prisoner than they do per public-school pupil? What does it say about us that the only thing our nation will guarantee every child is a costly jail or detention cell, while refusing them a place in Head Start or after-school child care, summer jobs, and other needed supports?

ACKNOWLEDGMENTS

"No one cares what we think. They haven't experienced it." That's what 15-year-old Jose Eduardo Hernandez, a detainee in Laredo, told me. "You see what we feel, you see what we think." For the opportunity to do that I'm deeply indebted to the professionals at the Webb County Juvenile Justice Center. To Judge Jesus Garza and Judge Alvino Ben Morales; to Melissa Mojica, the chief probation officer, and Juan Manuel Cavazos, the head of detention; and to Pat Campos and all of the detention and probation staff, I want to express my heartfelt gratitude.

I am especially thankful to Mr. Joe Espinoza, the gang intervention facilitator at Laredo United Indepen-

dent School District, who believed in this project from the outset. Joe, who is deeply respected by the youth of the community—it is said that he could walk into the middle of a gang fight without anyone hurting him—put his credibility on the line to make this project possible. Adam Rodriguez, whom I always introduce as "my probation officer," put his excellent reputation on the line as well by introducing me to his chief and recommending that she approve this project. He was and continues to be an inspiration. Sylvia Ortegon and Leo De La Garza were a joy to work with and to watch at work, as were so many of the probation and detention staff. I deeply admire their unwavering commitment to the children of Laredo.

Bart Lubow of the Annie E. Casey Foundation believed in this project when no one else did and made sure that funding was there to complete it. This book would have been impossible without his help and that of Myron Miller and his family of Boston, Massachusetts, who were incredibly generous in their assistance. Furthermore, I'm proud to have been the recipient of the Soros Criminal Justice Journalism Fellowship in 2004. This will allow me to continue to expand my work on this subject. I'm very grateful to George Soros, Kate Black, and the Open Society Institute.

My editors at *Time* magazine have supported this effort from its inception. To Jim Kelly, Michele Stephenson, Arthur Hochstein, Maryanne Golon, and all of my wonderful colleagues at *Time*, I express my heartfelt thanks. I want to say a special word of appreciation to Marge Michaels and Wendy Cole of *Time*'s Chicago bureau and to Eleanor Taylor, a former *Time* editor and great friend who shares my conviction that an important part of our job is to give voice to the voiceless. And to my dear friend Mary Studley, *Time*'s picture editor in Chicago, whose encouragement and advice have sustained me, I offer deep gratitude. Brooks Kraft, my friend and colleague at *Time*, knows how challenging a project like *No Place for Children* can be. I'm deeply grateful for his continued support and insight, and also for that of photojournalist Charles Ommanney, who was always an inspiration. My thanks also to Miriam Winocour and Clara Waldron at *Time*, both of whom patiently organized my chaotic expense accounts and kept me afloat while I was devoting most of my energy to this book. I'm grateful as well to Phil Simons and Jeff Jentgen at Franklin Capitol, and Chris White at Evanston Bank, who have done the same for me in Chicago.

This project has often been emotionally draining, but I've been sustained throughout by an extraordinarily talented and energetic group of young interns. They recorded the interviews, transcribed them, helped edit the sound and pictures, stayed up all night with me at the detention center, and reminded me that there are young people who care. To Jesse Drury, a consummate young professional who spent almost an entire year working on this project and did a great job, and to Brandon Aitchison, David Lienemann, David

Miller, Bob Tekavec, and J. R. Shedd, all of whom did terrific work in Laredo, thank you for your contributions. My assistant Brenna McLaughlin, a talented photographer in her own right, came to Texas to help and then went home to Chicago and worked tirelessly organizing and editing the negatives and proof sheets. Tony Lopez, a young Laredo native and a gifted artist and writer, spent an eternity conducting interviews in Spanish and then translating and transcribing them. He also gave me an invaluable sense of the local culture and an appreciation of what it was like to grow up in Laredo.

I've been blessed with friends who have encouraged and supported me in this project, in my career, and in my life. To Peter Wilson and Susan Lapides; Evan Richman; George Giglio; Harvey Dulberg; Jon Lowenstein, Jonathan Brill; and Rita, Bruce, and Tomas DiMedici, thank you for being there for me. And to Rick Friedman and Ira Wyman, two of my oldest friends and colleagues from Boston, a special word of thanks. We have always been there for each other, and I'm so glad to call you my friends.

I was lucky to have two fine photographic labs involved in producing this book. I'm grateful to John Ybarbo and Austin Photo Imaging for their superb work processing and scanning the negatives, and to Ron Gordon, Sandy Steinbrecher, Emma Rodewald, and Chris Ferrari at Ron Gordon Studio in Chicago, master printers who made the beautiful 11 x 14 prints reproduced on these pages. Scott Dadich, that most gifted art director at *Texas Monthly*, and Executive Editor S. C. Gwynne were generous with their time and their talent. Carolyn Young and Freda Hamric of the Hogg Foundation were always willing to give of their time, expertise, and passion, as were Earl Dunlap and Michael Jones of the National Juvenile Detention Association, Vincent Schiraldi of the Justice Policy Institute, and Jim Jones and Morna Murray of the Children's Defense Fund. Thank you for that. And a special thank you to Rep. Richard Raymond from Laredo and his aides Chuy Gonzalez and Sergio Mora, who supported this project and worked hard to raise funds for it. Steve Hall, project director for *StandDown Texas*, has taken time from his own important work reforming the death penalty in Texas to help with *No Place for Children*. His assistance was invaluable, as was that of Peter Loge of M & R Strategic Services in Washington, D.C. I am also grateful to my friends at Canon USA, who loaned me some of the finest and fastest lenses available for shooting in the nonexistent light of a jail at night. Without those marvelous lenses many of these pictures couldn't have been taken in the first place.

This book would have been impossible without the creativity of two multi-talented editors and designers. Rick Boeth, who was my picture editor for many years at *Time*, was a constant source of guidance and inspiration throughout and did his usual masterful job editing two years' worth of photography down to the final pictures

for this book. Dennis Brack, Jr., whom I've known since he was an undergraduate at Northwestern, is a superb art director at the *Washington Post*; his vision is evident in every part of this project, from the writing to the editing to the design. No one could ask for better collaborators or friends than these two. Additionally, I offer special thanks to Roy Flukinger, senior curator of the photography collection at the Harry Ransom Humanities Research Center at the University of Texas, for his faith in this work. Dr. Brenda Schick, Professor of Speech, Language, and Hearing Sciences at the University of Colorado at Boulder, was an invaluable advisor, as was Dr. Simon Mole, a court facilitator and magistrate for the state of Colorado. Professor Steven Raymer of Indiana University, a 20-year veteran of *National Geographic* and himself the author of many books, gave freely of his wisdom and expertise.

Two of my very oldest and best friends invested their considerable talents in this project: Michelle Keenan, director of the Regional Center for Healthy Communities in Cambridge, Massachusetts, is an expert in social advocacy and one terrific grant writer, and Christie Smith, who teaches composition at Denver-area colleges, is an author and editor par excellence. They were my sounding board and my advisors throughout and I cherish their friendship and their many contributions to this book. Another long-time friend, Pete Leon, is legislative director for New York Congressman Elliot Engel. He helped gin up support for this project in political circles. Thank you, Pete.

Though the parent of none, I've been the mentor of many: Cory Mason, Ryan Schick, and Caleb and Erik Stone are grown up now and doing wonderful and exciting things with their lives. Erik is a teacher living in Japan, but Cory, Ryan, and Caleb were all involved in producing this project, including working with me on location in Laredo. Thanks, guys. Your success and happiness continue to inspire me and I'm proud of you all. And to George Roland, and his wife Mary, who taught me how to be a mentor and how to nurture creativity, you are simply the best.

Finally, to the children of Laredo who confided in me, and to the families who opened their homes and their hearts to me, I offer my deep and inexpressible gratitude. Cindy, Danny, Gabriel, Holkan, Israel, Ivan, Jose Eduardo, Jose Luis, Mike, Rene, Rolando, Rogelio, Santos, Tommy, and Zulema: I hope that, through this book, I may be able to keep my promise to you to try to make things better for all kids, especially those who are in trouble. Thank you for trusting me with your life stories. Thank you for that gift.

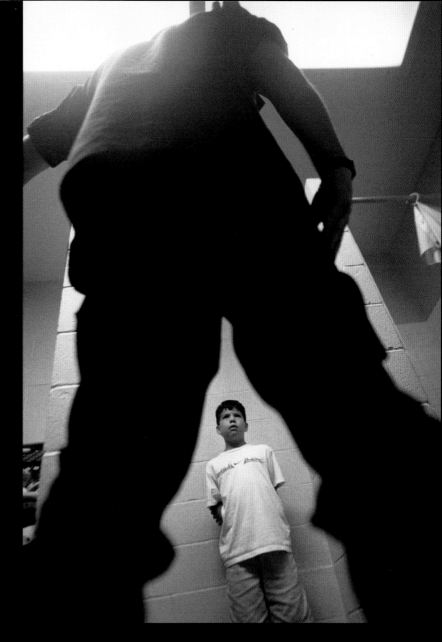

NO PLACE FOR CHILDREN

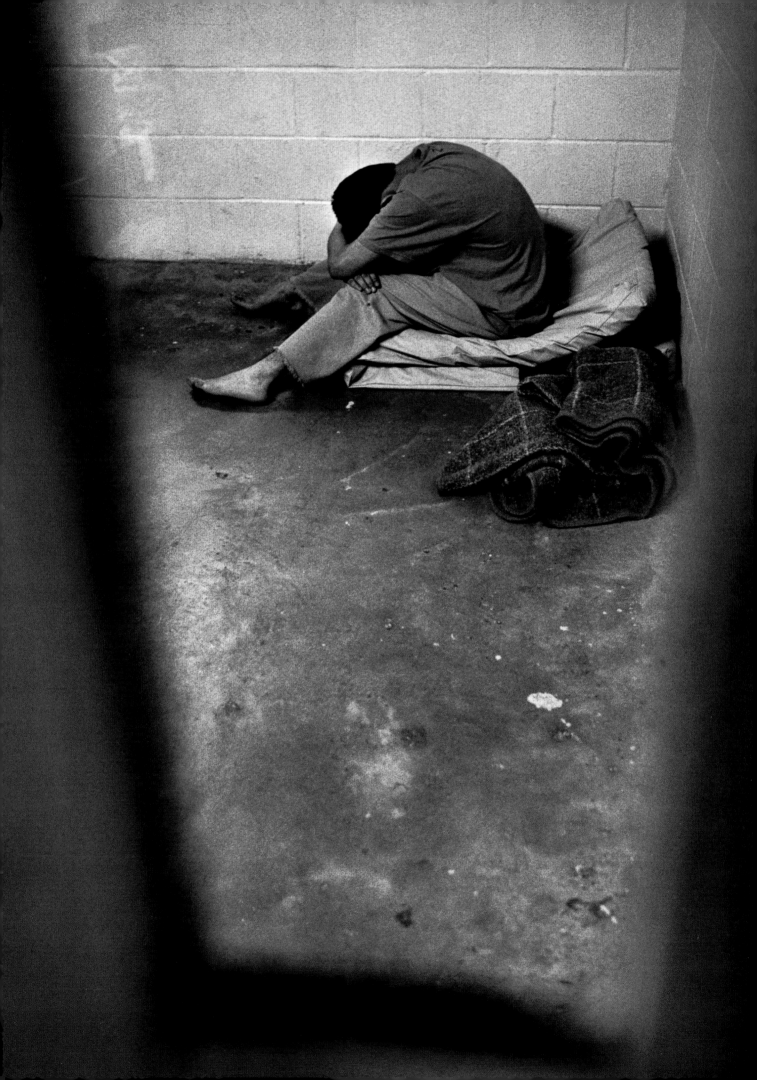

CECILIA BALLÍ

INTRODUCTION

This place was not meant for children.

This is the world of young felons, of kids gone astray, of children who cry for their mothers from behind bars. Some have skipped class too much, some have murdered in cold blood. At least half of the kids have been incarcerated before. And, if society's attempts at rehabilitation ultimately fail—or if the parent can't or simply won't do anything to turn around years of neglect and abuse—just a few more visits to juvenile detention will harden some of these kids into full-fledged adult criminals. What many Americans don't realize, however, is

THEIR WORLD, REDEFINED
Sadness, loneliness, and helplessness fill the cell blocks in Juvenile.

that these children are starved for attention, wanting to be understood and needing, urgently, to tell their stories.

Throughout the country, state governments have created structures, ostensibly to protect young offenders, that are predicated on anonymity and silence. How we treat our most at-risk kids is perhaps the best-kept secret in the United States today. The community of Laredo, Texas, however, is determined to let others learn from its experience. Parents, probation officers, and youth welcomed photojournalist Steve Liss into their homes and into their detention cells. For two years, Liss, a 20-year award-winning photographer for *Time* magazine, chronicled Webb County's juvenile system. By building networks of trust, he was given unprecedented access to the detention facility where he photographed daily life and recorded lengthy first-person accounts of juveniles who have been pushed to the fringes of society.

More prisons, less rehab

This story is unfolding everywhere in the United States, from the heartland to the borders. For more than a century, the mission of the nation's juvenile justice system was to rehabilitate troubled youth and give them a chance to get their lives on track. Then, in the late 1980s and early 1990s, a short-lived increase in juvenile crime caused a dramatic transformation of the system. Public opinion polls showed increased support for locking up young offenders, and state legislatures responded. Since 1992, the juvenile justice systems in 47 states and the District of Columbia have embraced incarceration and detention instead of treatment and prevention.

Meanwhile, funding for rehabilitation became harder and harder to come by. "Even when the money was there, there wasn't a natural tendency to invest in rehabilitative programs," says Richard Raymond, a Texas state representative for the Laredo area. "It's still not a priority, even though studies have shown that the rate of recidivism drops dramatically if you have rehabilitation services." For instance, between 2001 and 2003, the Texas legislature eliminated almost all mental-health benefits from the Children's Health Insurance Program for juveniles who have passed through local probation programs. Moreover, there has been a fundamental disconnect between policy and reality: Although the arrest rate for violent juvenile offenses declined by 33 percent since 1993, the

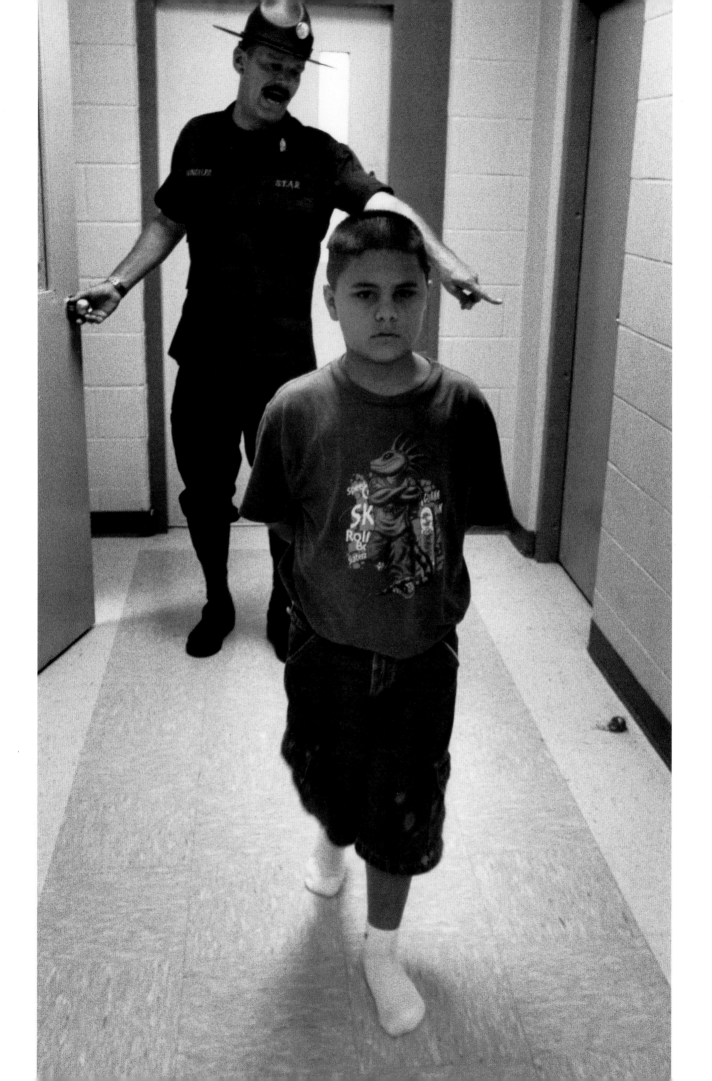

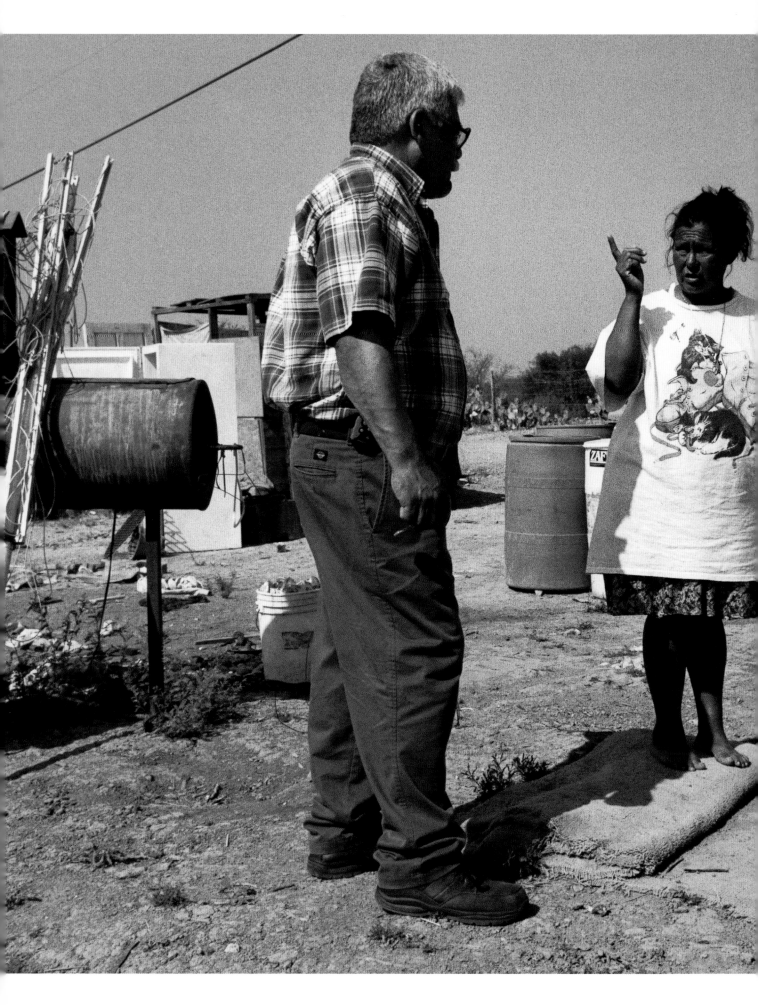

NO PLACE FOR CHILDREN

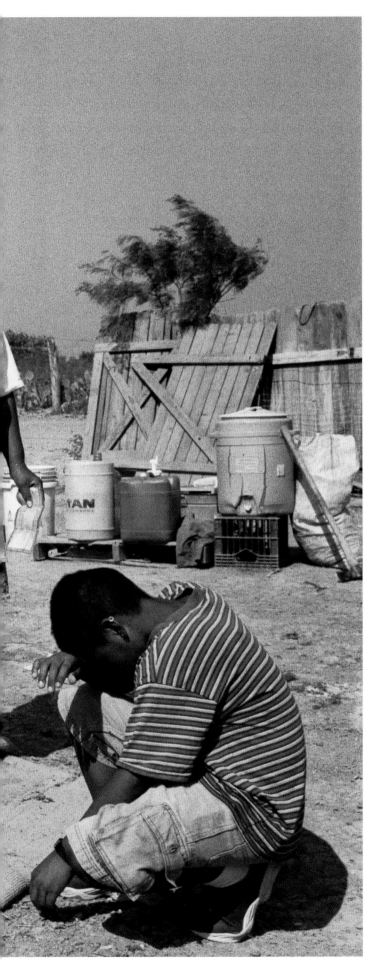

number of children incarcerated for lesser crimes increased. In too many communities throughout the United States, this trend continues today.

Seeking help, sent to cells

Of the many troubling facts about juvenile detention, perhaps the most disturbing is that many children should not be there at all. How many of our young "criminals" are really children in distress? Three-quarters of children detained in the United States are being held for nonviolent offenses. Many of these children are substance abusers, and, according to the Coalition for Juvenile Justice, anywhere from 50 to 75 percent of them have some form of diagnosable mental illness. But juvenile detention was never designed to meet the treatment needs of kids with psychological and drug problems. While in detention, these troubled children receive minimal services, at best, and the effects of incarceration can be devastating. "If a child has been neglected, the last thing you want to do is put him in a cell," says Homero Sanchez, a Laredo psychiatrist who treats young patients. "It's like putting him in a closet." Kids under 12 or 13 years old are especially vulnerable. In fact, children as young as 10 are incarcerated in detention facilities, however inappropriate a jail setting may be for kids of that age.

Behind barbed wire, breeding criminals

Behind the barbed-wire fence of the Webb County Juvenile Detention Center, the world loses its shape and takes on the contours of cinder-block cells with steel beds bolted to the floor. The only color is the bright orange of the uniforms that are several sizes too big for the youngest guests, some of whom are only 10 years old. Regardless of age, the system does not discriminate: Children who

have shoplifted, graffitied a wall, or run away from home sit next to kids who have shot and stabbed people. Others wriggle on the floor in restraints in the next cell, screaming as they experience the symptoms of drug withdrawal in the emptiness of a jail cell.

Detain, detain, detain

The trauma of incarceration is cause for concern for anyone interested in the well-being of young children, yet the emphasis on locking kids up seems to be based on the belief that children can be scared stiff into behaving before they even go to trial. "When I come here on Monday, Wednesday, Friday, my goal is detention, whether it's a first-timer or someone who has been here a couple of times," says Madeline Lopez, an assistant county attorney who prosecutes juvenile offenders in Webb County. "I want every kid here detained because I strongly believe that by being in here, by mixing with the kind of people that you're going to mix with back there, they'll see some type of consequence to their actions. I'd rather that they mix with those people." But that approach often backfires. "All of a sudden you have the first-timers being trained by multiple offenders," says Adam Rodriguez, a Webb County probation officer. "Ten days later you release this kid and you've got a little monster, because he's learned how to pack a .45, how to do a drive-by and be able to abscond from the police."

Politicians have found a popular platform in initiatives that are "tough" on kids and crime. When George W. Bush was elected governor of Texas, he promised "zero tolerance" and pushed through a series of laws that transformed the structure and tone of the state's juvenile justice system. In 1996, the Texas Juvenile Justice Code was rewritten to explicitly "promote the concept of punishment for criminal acts." The law introduced an inflexible series of mandatory punishments for every type of behavior problem, from running away from home to armed assault. Probation officers—and even judges—have little discretion. "A lot of the behavior that we ourselves used to do as kids has now been criminalized," says one probation officer. "Kids are going to get in fights.

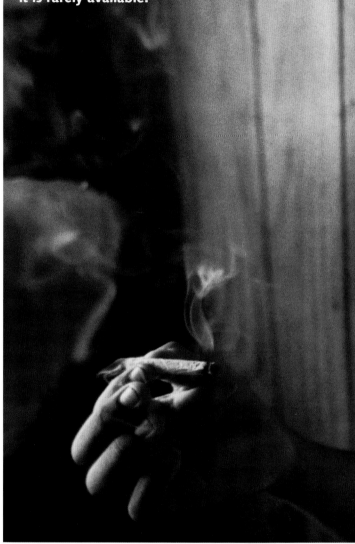

ON THE EDGE
So often it begins at a young age, as with this 10-year-old experimenting with marijuana. Early intervention, which kept this boy out of Juvenile, could help others. But it is rarely available.

Kids are going to break things." The key fact overlooked by prosecutors and politicians who advocate zero-tolerance policies, however, is that children may act like adults, but they still think like children. They don't respond to punishment the same way that adults do, which means that placing a child in a locked-up facility often has unintended consequences. Instead of learning to avoid future misbehavior, first offenders try to emulate the more experienced delinquents they meet in detention.

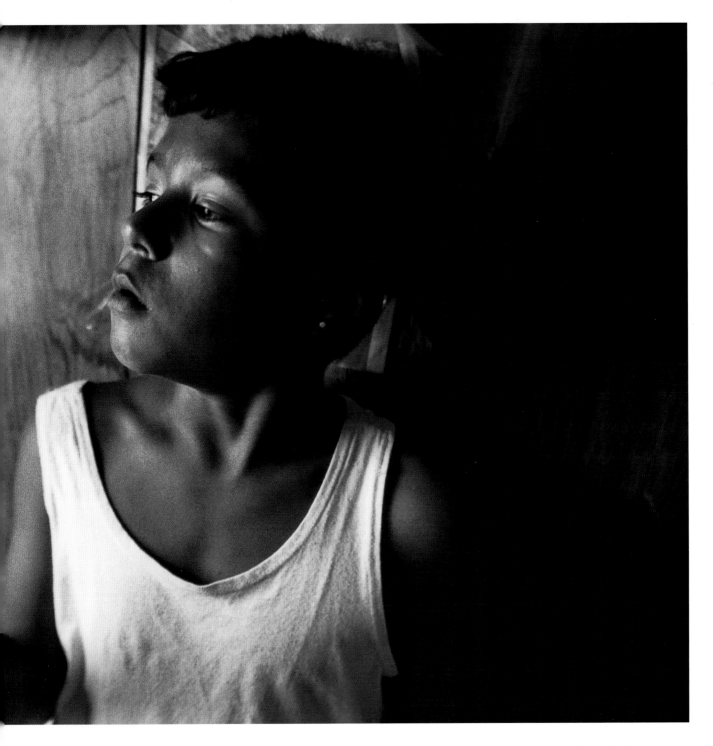

One mistake—and labeled for life

The process leaves its stigma. "Once a child's been here, he's labeled and people start making all kinds of assumptions," says Pat Campos, director of case management at the Webb County facility. After a few appearances in Juvenile, even the child begins to understand that, in the eyes of others, he is little more than a criminal. "You need to be very careful what you tell children because you don't realize how powerful your words are. If you tell a kid something that hurts him, he'll never forget

Every kid makes choices, but kids are not to blame for the poverty around them, for a culture that elevates guns to status symbols, or for the drugs they can score as easily as a Popsicle at the corner store.

that," she adds. Meanwhile, destructive emotions fester. "A lot of these kids are just angry," says probation officer Rodriguez. "Angry because there's been no attention, no love, no nourishing."

A call to action

"And yet, beneath their despair and anger, these young offenders are just children, most of them intelligent and likable," says photographer Liss, after spending hundreds of hours with the subjects of this book. By giving a human face to the statistics on juvenile crime, Liss hopes that his pictures will challenge everyone to see these children not as a social ill, but as a social responsibility. Reversing the trend of criminalizing youth requires visionary thinking and community-wide collaboration. Schools and churches need to educate and support parents in the complicated business of raising children. Educators need to face up to the growing problems of drug use and mental illness; they need to address these issues while they can still make a difference—in elementary schools—before children's emotional problems escalate into misbehavior or violence. Communities need to provide halfway houses and counseling for runaways, while agencies need to overcome internal squabbles and work together to create a continuum of rehabilitative care. State judicial systems need to recognize differences in the ages and needs of children. And elected officials need to make financial commitments where they count. We need to stop being afraid of our children and begin saving them.

We've failed these kids

"They needed help," says Campos, the case management director, in a moment of candid reflection, "and somewhere along the line we failed these kids. We failed to educate them, we failed to educate their parents, we failed to provide for them. And all of us have to pay in the end."

Children deserve better.

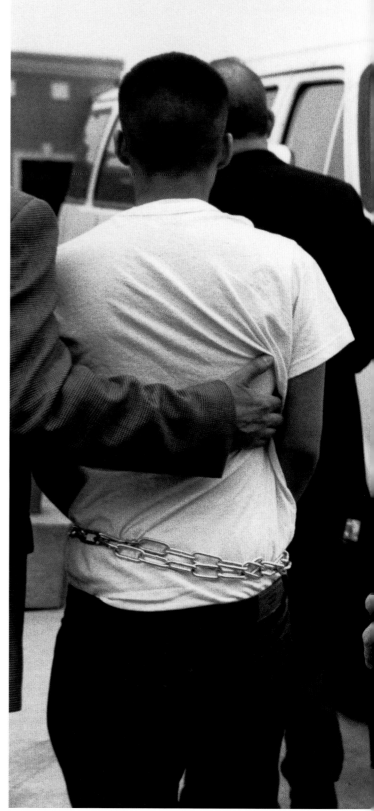

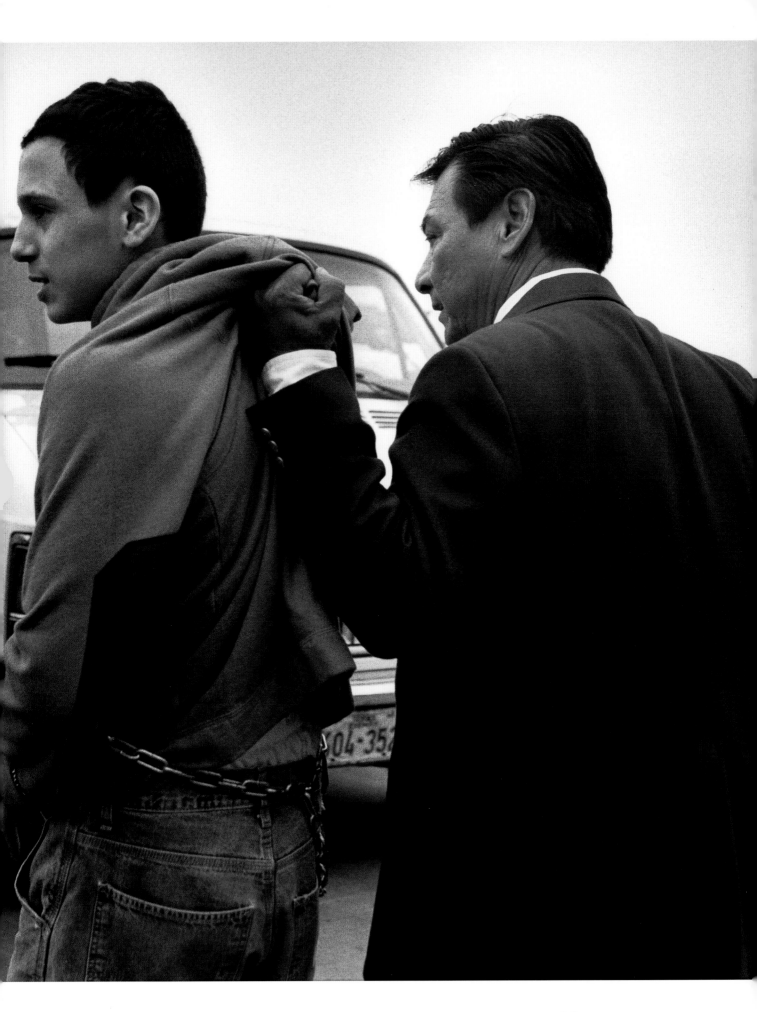

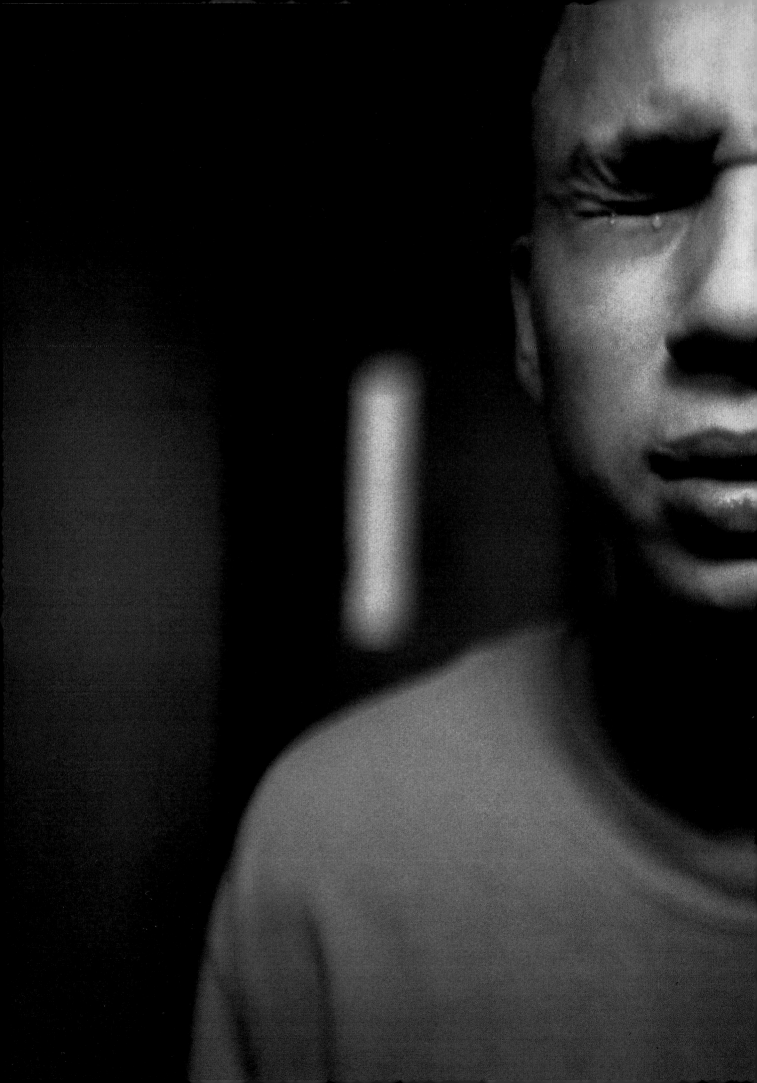

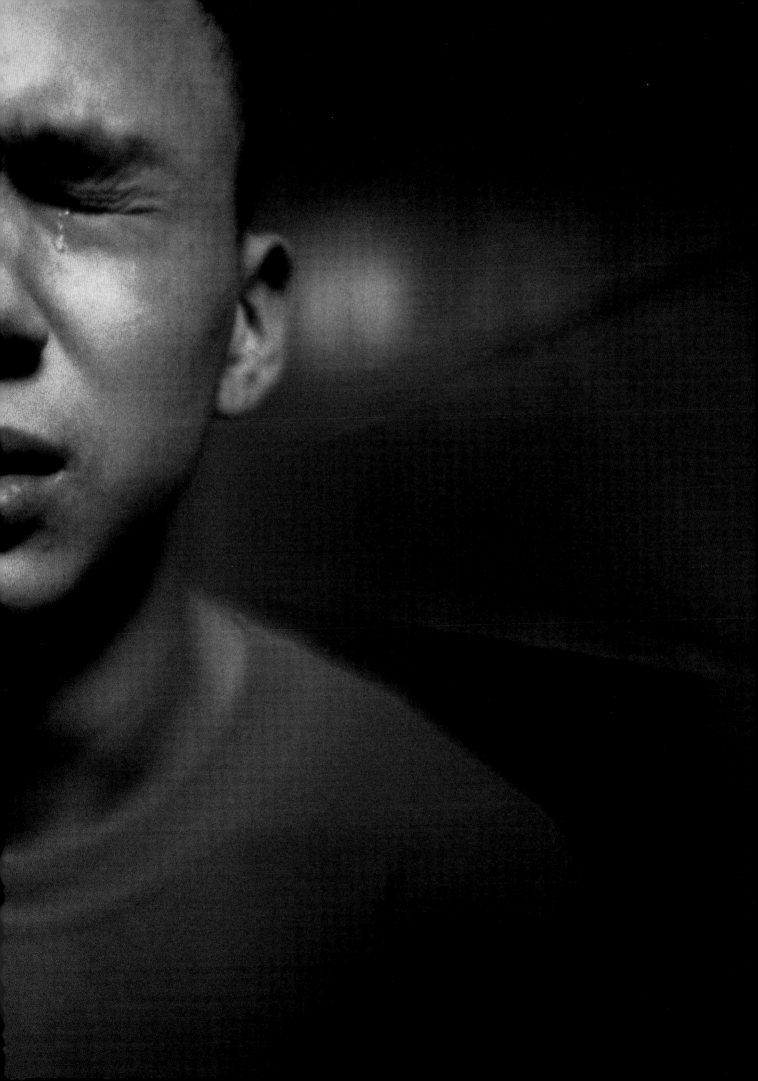

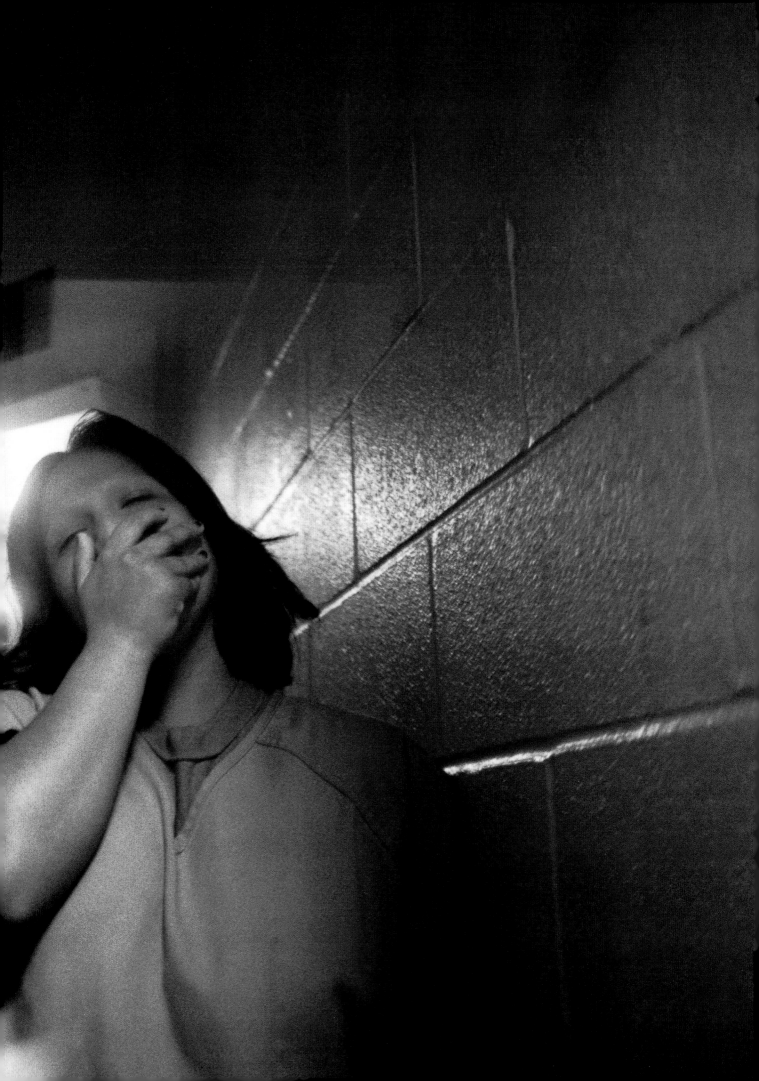

NO PLACE FOR CHILDREN

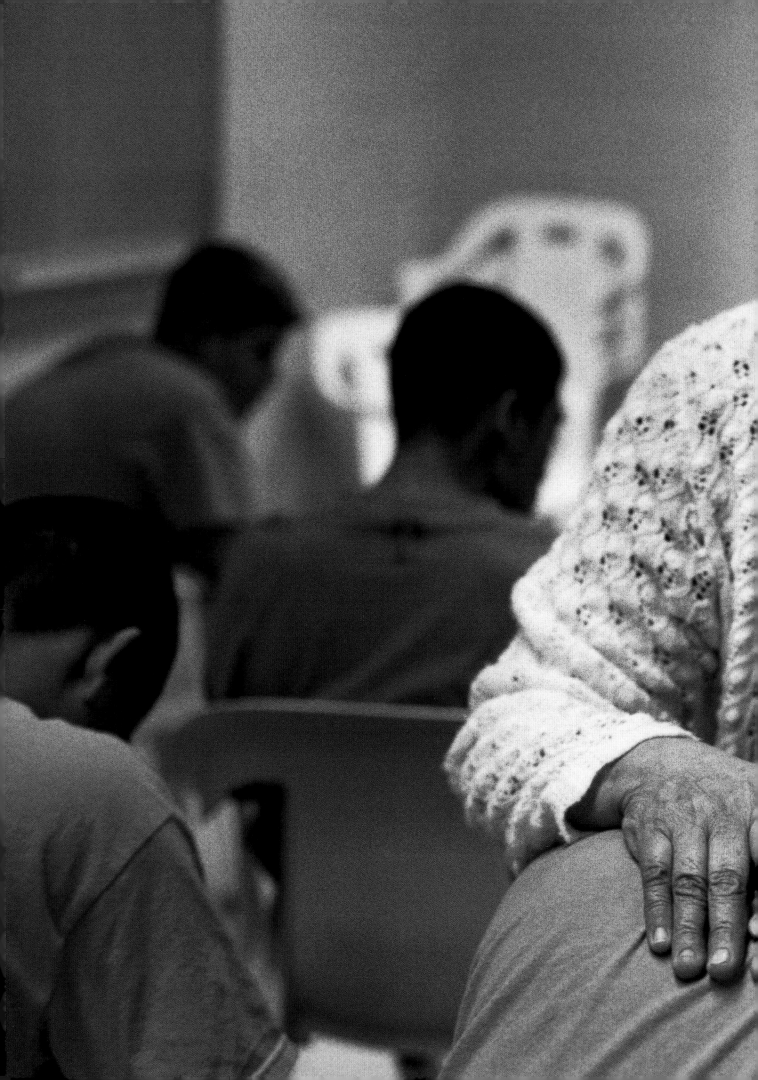

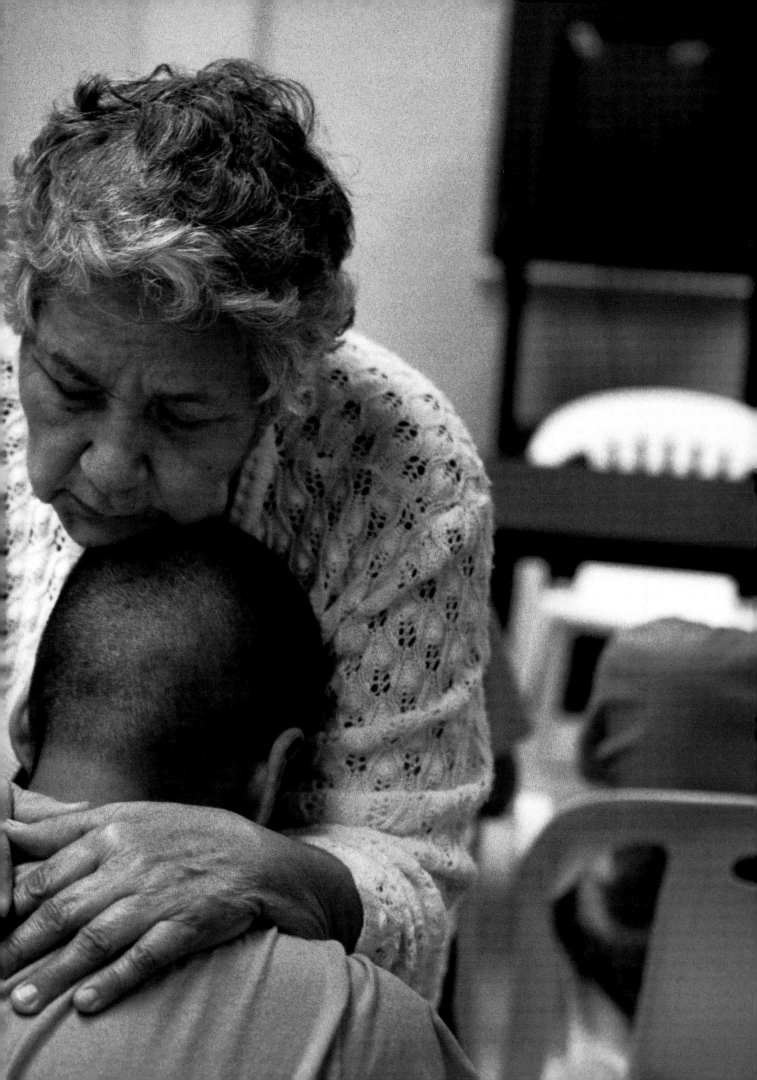

THE KIDS
THE SYSTEM
IS FAILING

It sounds harmless: "pre-trial detention." But the reality is far different. In a squat block building in Laredo, Texas—and in similar places around the nation—children await trial or placement in concrete cells while the underlying issues that led to their behavior fester. Some are addicts who need treatment; others are kids battling mental illnesses. Many are angry and have been virtually abandoned by absentee or irresponsible parents. Some spend a few days, others months, but despite the efforts of a small corps of dedicated professionals, few actually receive treatment for the issues that brought them to Juvenile. These are some of their stories.

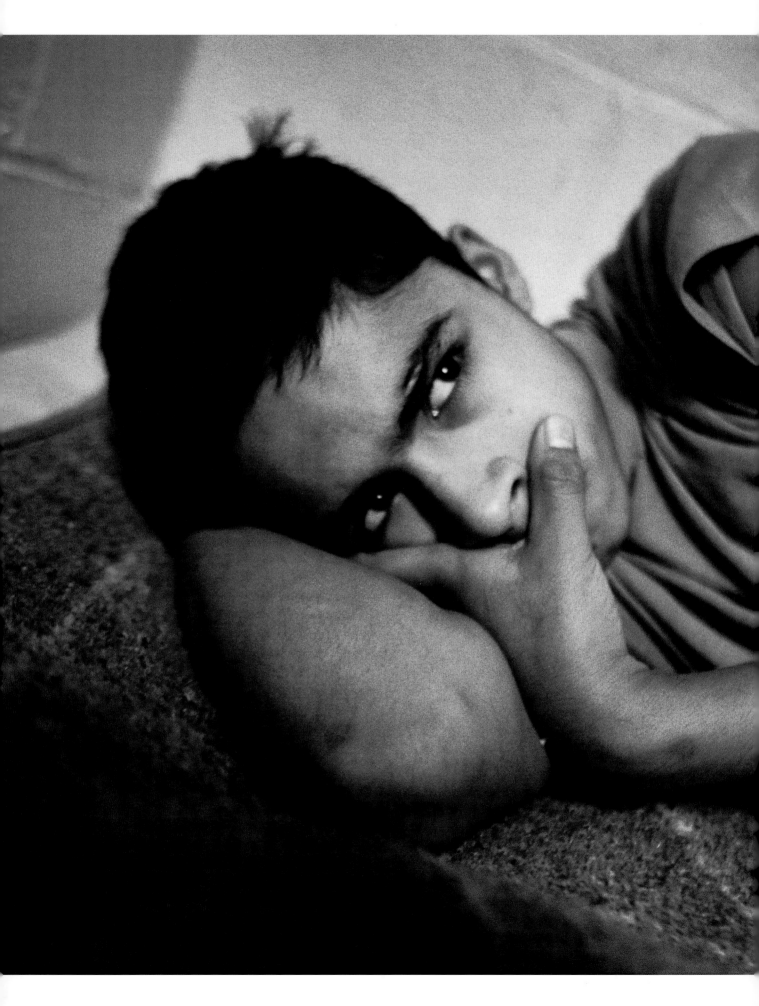

NO PLACE FOR CHILDREN

Jose

"I think I'm a good person,
but when they get to me they get to me."

Jose, 14, is back in Juvenile because he ran away from home. He's good at running away from his problems. There was the time Jose was sent to a residential halfway house. He mused aloud to his escorts that the place was not fenced in and the windows were open. Two hours later, he was gone. But there's more to Jose's story. He admits he's drunk, but a guard suspects he's high on drugs. And he's angry. Jose is often angry. Little things set him off—and get him in trouble. So, Jose keeps landing in Juvenile. There's no other place for him. But, as Jose seethes in his cell, his problems go untreated.

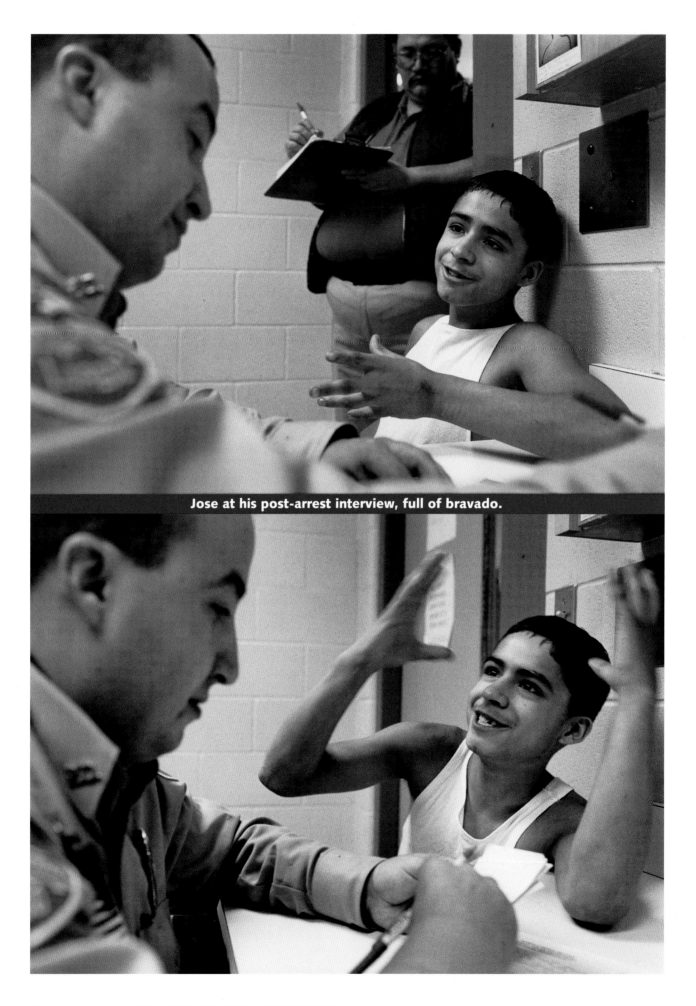

Jose at his post-arrest interview, full of bravado.

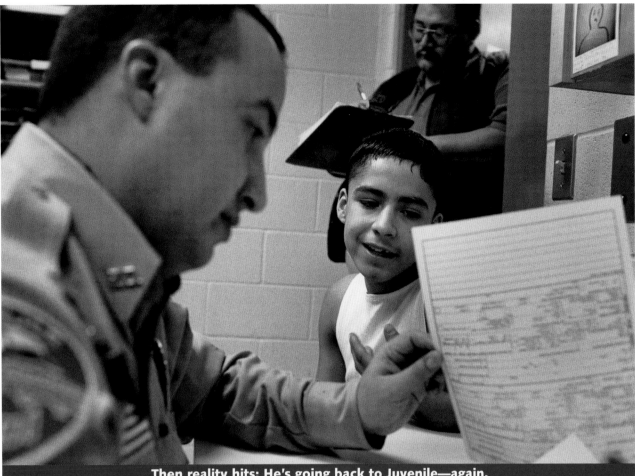
Then reality hits: He's going back to Juvenile—again.

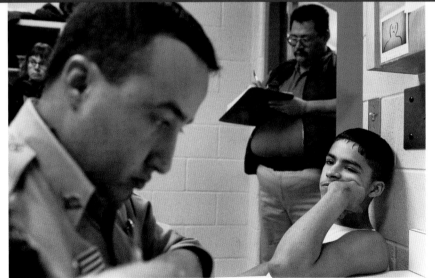

"I've never been scared in my whole life.

"I stole my father's car last summer. I was 13. When everybody fell asleep, I just pushed it a block and I turned it on. I stole 400 dollars and drove to Dallas.

"I had a .357 revolver with a friend, and I said, 'Hey, let's play Russian Roulette.' And I just put one bullet and I spinned it. . . . I pulled the trigger, then he pulled the trigger, then I pulled the trigger, then he pulled it again. We were just playing.

"When I come out of Juvenile, that's the happiest day of my life."

Longing for his jailed mother,
Jose is being consumed by drugs and anger.

His probation officer Sylvia Ortegon explains: "His mother is in prison and all he wants is to have his mother. That's all he wants. His mom. He received a phone call from his mother while he was in detention and she told him, 'When I get out of here you're not going to do what you're doing now.' And he was so happy. He was so happy. He told me, 'When my mom comes out, I will behave, Ms. Ortegon. I will behave.' But his mother is gonna be in prison for six years. . . . He is a very likable kid, and he tries. But there are so many obstacles that he needs to overcome, and he just isn't able to."

Jose, waiting for his court appearance.

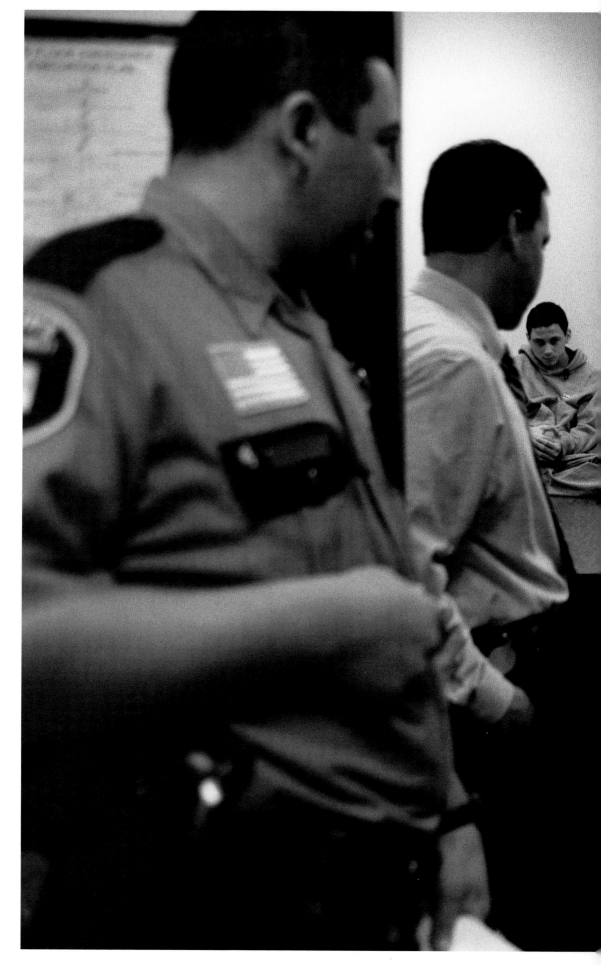

Jose listens as the prosecutor presents the case. Without enough rehabilitation, psychiatric, or detox facilities, the judge has only two choices: back to Juvenile, or back to the streets.

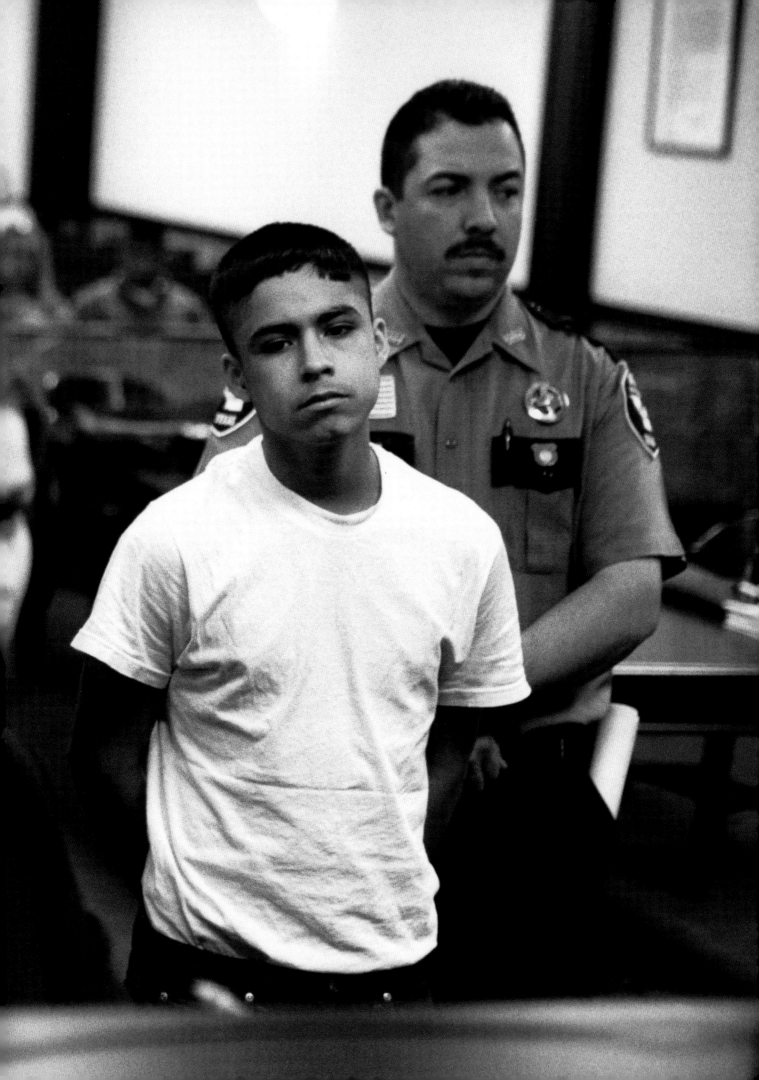

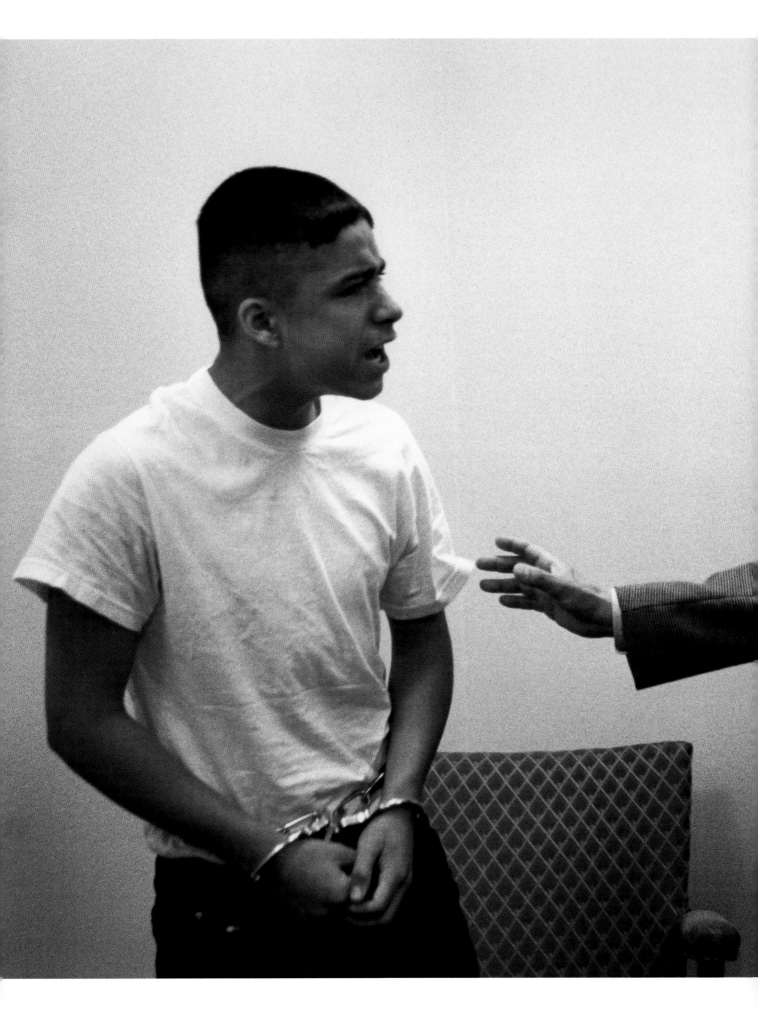

NO PLACE FOR CHILDREN

Jose talks with
probation
officer Cesar
Ehrenzweig
after a hearing
at which he was
committed to
the Texas Youth
Commission.

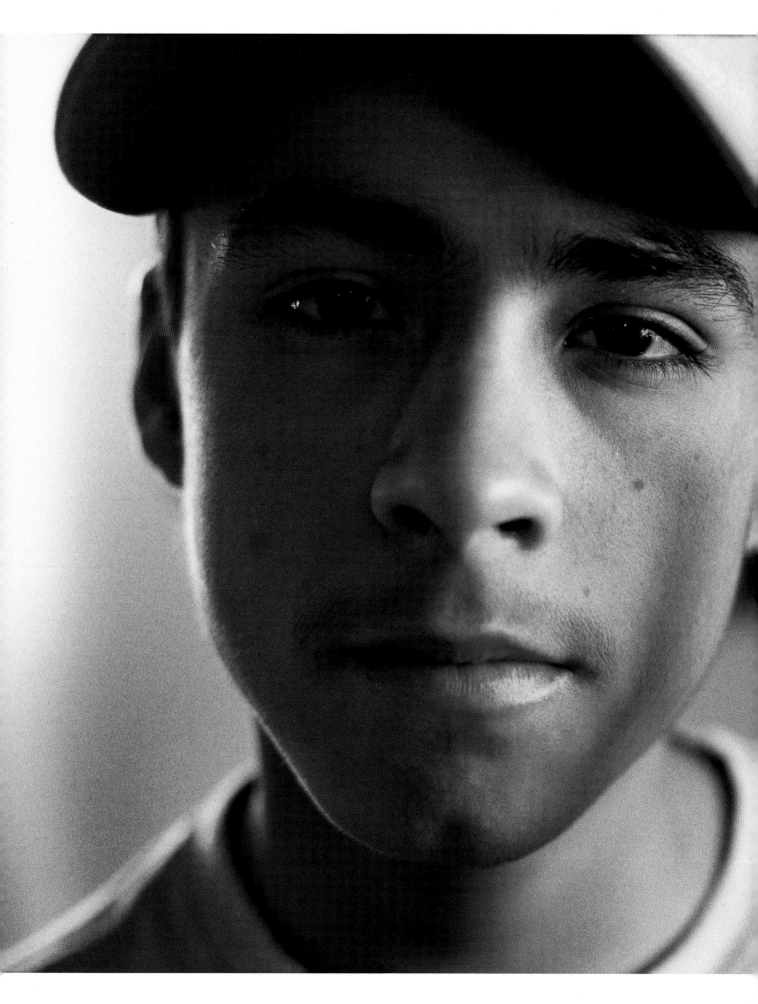

NO PLACE FOR CHILDREN

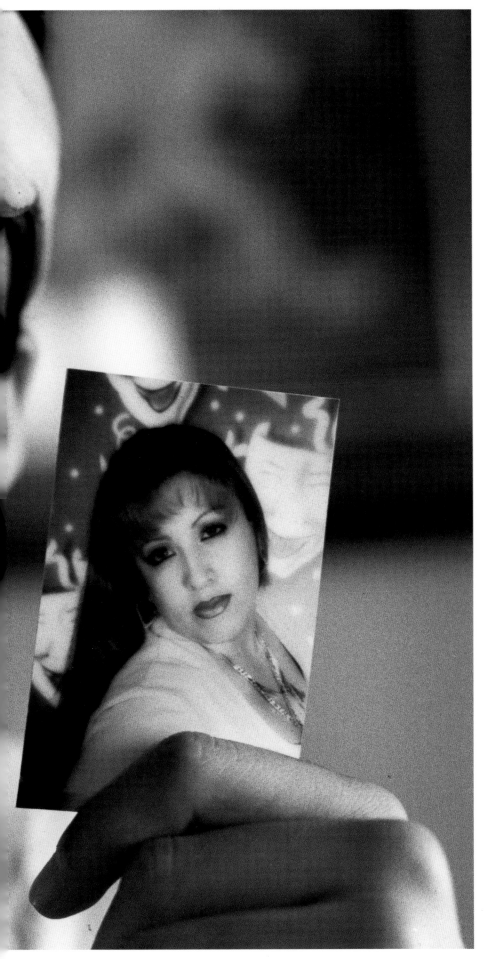

"I miss my mom. I'm living with my grandma because my mom's in jail in San Antonio. They caught her with $1.6 million dollars of drugs. I don't know if she was selling it or running it. I haven't seen her for a year. Before she comes out she wants me in school. I don't go to school. I just hang around with all my friends."

"It's because all of my family on my dad's side are all aggressive. That's what my mom says, that I have my dad's blood."

JOSE, HOLDING A PHOTO OF HIS MOTHER, ON HIS TEMPER

Kris

"I want to go home. . . ."

Even after more than a dozen trips to Juvenile, it doesn't get any easier for Kris, 14. He doesn't know exactly what he did to end up here this time, but Kris knows it probably involved his drug-addicted alter ego. "You went wild," says his dad, who once again is at Kris's side when he comes to. And once again, Kris says he wants to beat drugs, but he needs more help than his dad is able to provide. He needs rehab, but that's not what he's getting. Instead, Kris is getting a tour of the juvenile system at its worst—countless canceled court dates, no-show lawyers, judges who won't order rehab.

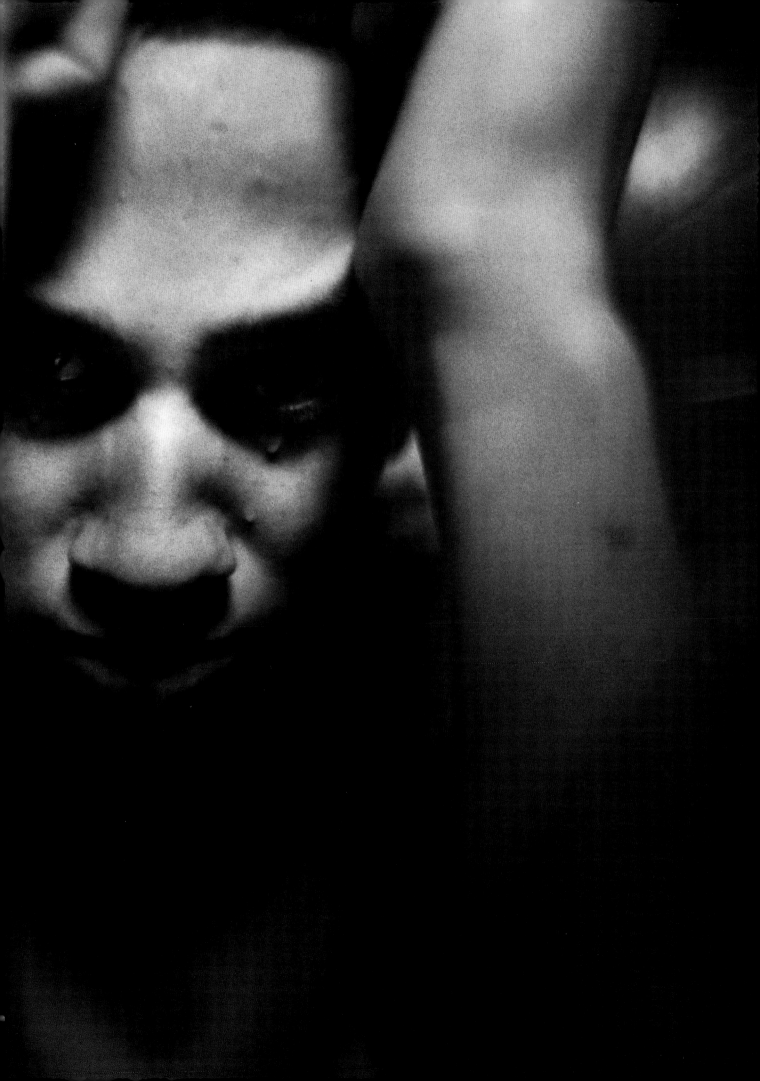

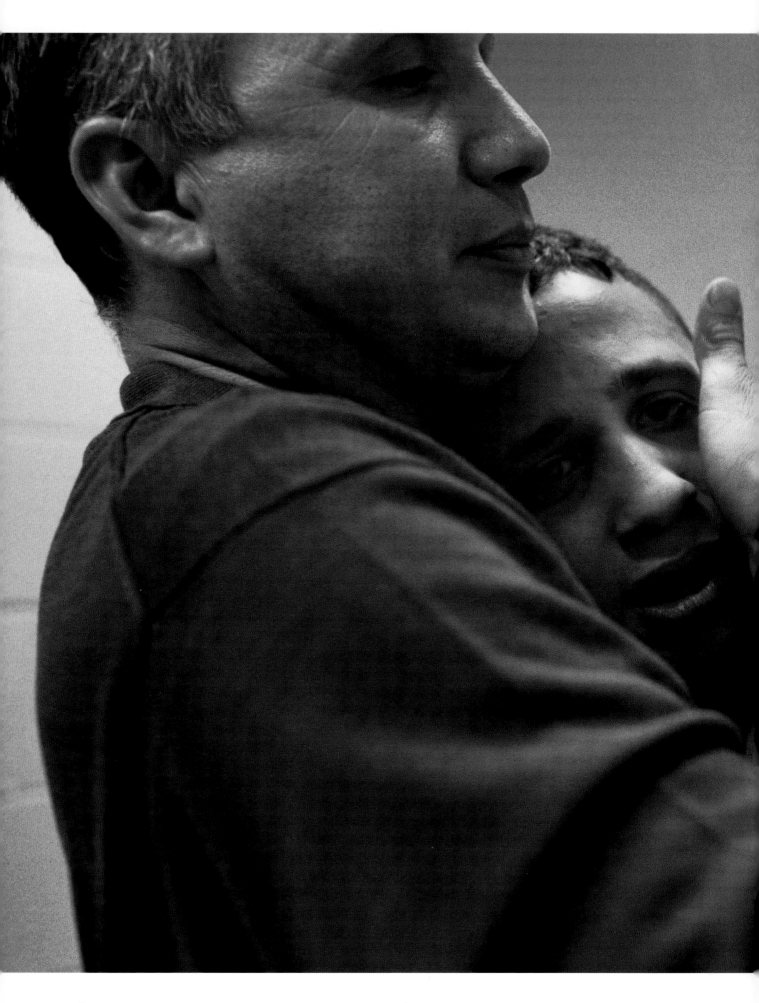

NO PLACE FOR CHILDREN

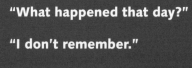

"What happened that day?"

"I don't remember."

"Did I hit you?"

"I don't remember, Dad."

He was there for his son.

Kris is lucky to have a dad who cares—a dad who cares, and confronts a system that seems as if it does not. A father's story:

"About a year and a half ago, when Kris started getting in trouble, he got probation. I talked to the probation officers. I said, 'I'm out here begging for help. I want to do something about Kris. He has a drug problem. I want to send him to rehab.' Well, nothing ever happened, obviously.

"We're here again. This is like the twelfth time that he has been here. The writing is on the wall that something is wrong with the little boy. Last week, when I talked to his probation officer, he recommended TYC [the Texas Youth Commission, which is given custody of the state's most violent and chronic delinquent offenders]. I said, 'No! TYC—there's worse kids there! What happens if he goes in there and he comes out worse? You know I've been asking for help. I would have voluntarily sent him to rehab.' And he goes, 'No, it has to be judge's orders.' And I said, 'But I'm the parent. I have a right to send him!'

"I called Evergreen Rehab Center in Hondo, Texas. I talked to the gentleman there. . . . He goes, 'Is he on probation?' I go, 'Yes, sir.' He says, 'OK, start with his probation officer. He is the only one that can recommend.' So, I called his probation officer on the phone. He never did anything about it at all. I've tried to make an appointment with the judge. They say he'll call me back. They never call. They have done nothing for him. Nothing! Zero!

"I've been to court so many times. . . . When we first went to court, the court-appointed attorney walked out and we never saw him again. Last time, when we went to court I go, 'Your honor, with your permission, I would like to have another lawyer, 'cause this guy . . . I've only talked to him once and I have had him since November. He's late now. He's not here. And he was late last month also. Can I have another attorney?' He just started with, 'Well, Mr. Lopez, your lawyer is a good attorney, da-da da-da da . . . and so on and so on.' Then he got upset and called recess. The judge went to the back and when he returned, the lawyer came in and just said, 'Retrial. Come back next month.'

"You just sit there for hours to be told your case will be delayed for another month. That's why these kids get into more trouble. 'Cause they just sit there and go, 'Well, they're not going to do anything to me anyway.' You know how kids think, 'I'm getting away with it!'

"So you go to court next month—again. And then the judge tells them, 'If I see you again in my court, I could send you up North.' Don't scare the boy! Do something about it! . . .

"I went to see the lawyer a couple of weeks ago. I went to his office—and he has the TV on while he is talking to me. This man is supposed to be a professional. His son is in the room while he is talking to me. The man is just there to collect a check. He doesn't care."

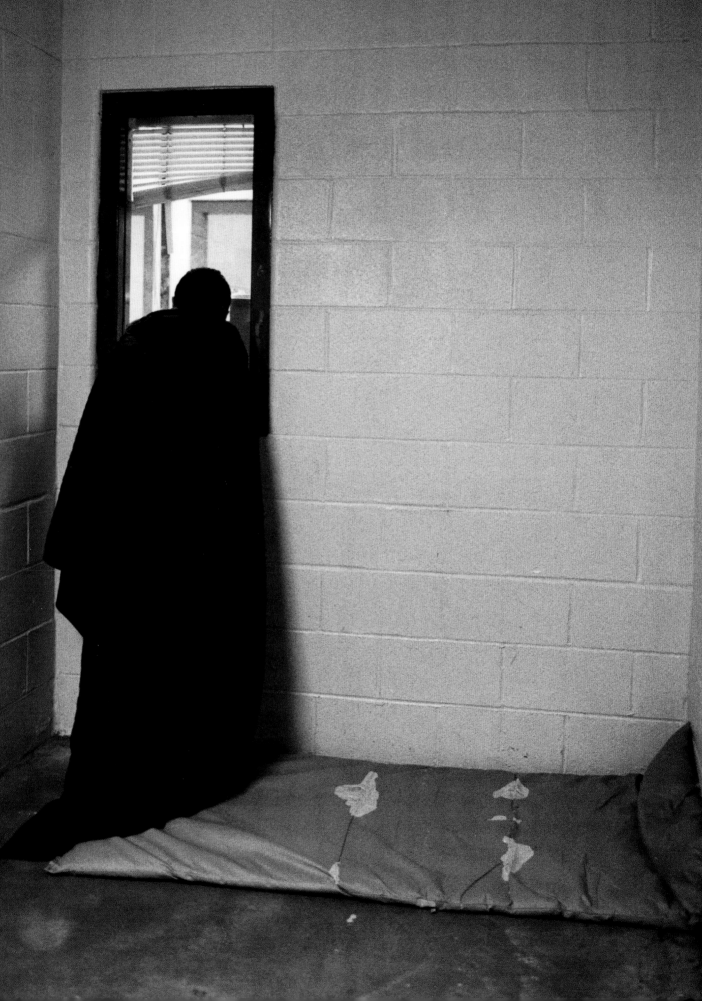

"I wanna change my life around.
I wanna be a new Kris."

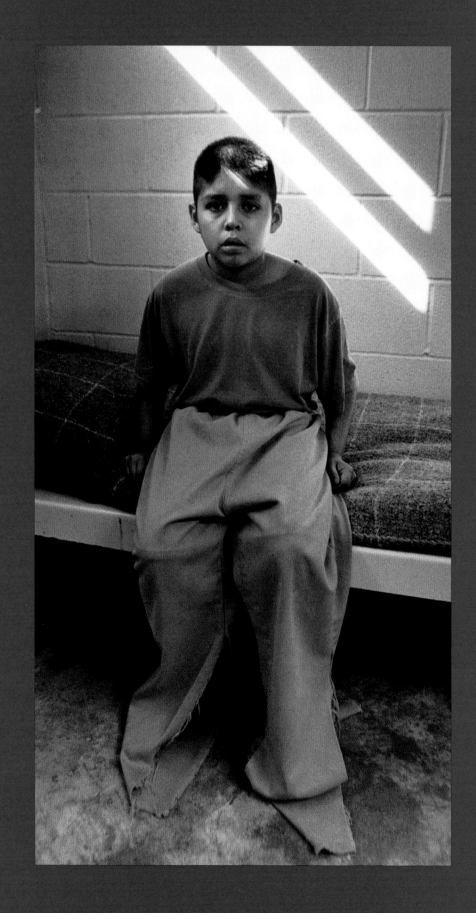

THE YOUNGEST

Their pants are too big. Nothing about the juvenile detention center—not the cinder-block cells, not the orange jumpsuits or the brown plastic slippers—seems made for children. And yet, every day the guests get smaller, and more confused about what brought them here. Psychiatrists say children do not react to punishment in the same way as adults. They learn more about becoming criminals than they do about becoming citizens. And one night of loneliness can be enough to prove their suspicion that nobody cares.

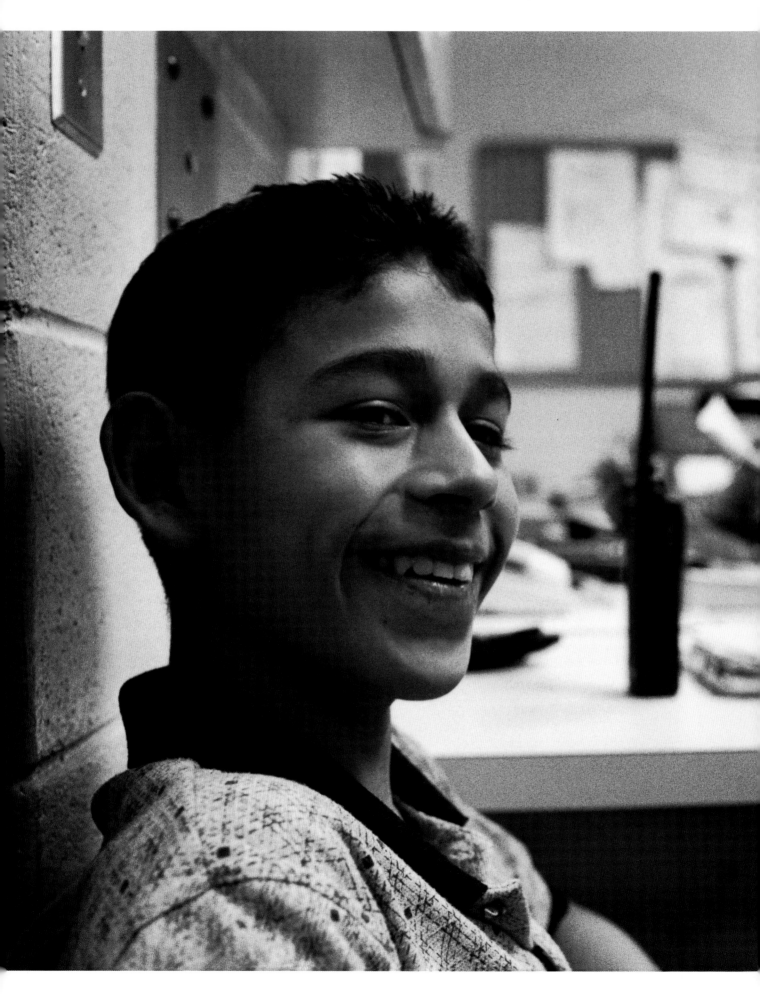

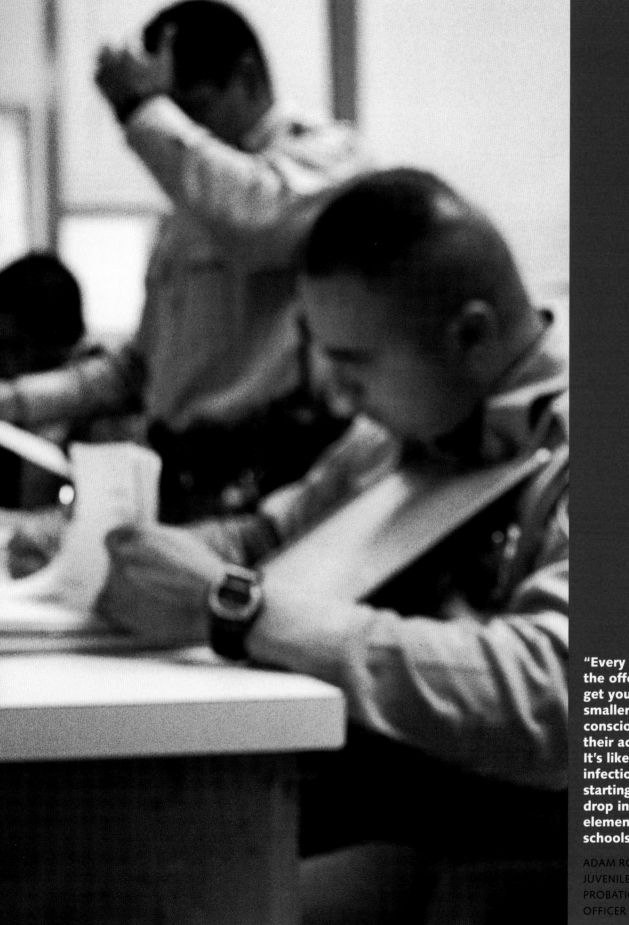

"Every day the offenders get younger, smaller, less conscious of their actions. It's like an infection that's starting to drop into the elementary schools."

ADAM RODRIGUEZ, JUVENILE PROBATION OFFICER

Homero Sanchez, a psychiatrist who works with troubled kids, on The System:

"Little kids are not gonna benefit from being jailed. I don't think there's anything to be gained from it. Because they're sponges, they're likely to learn a lot of things in jail we don't want them to learn. If a child has been neglected, if he's grown up without any attention, the last thing you want to do is put him in a cell. It's like putting him in a closet. A kid like that may need a residential treatment facility where they're gonna stay there, they don't have a choice, but it's more open, more treatment-oriented, family-oriented, loving-oriented. . . .

"You have to take into consideration not so much what did he do but what's going on with the kid. We find that many of the kids who are picked up for shoplifting, for instance, are depressed. It's their attempt to find something in life. . . . They're looking for something to lift them up.

"A lot of kids are doing adult things without even realizing the consequences. The prosecutors say, 'The way to teach children consequences is to lock them up.' Well, that may work for adults. Children and adolescents aren't gonna learn that. Their response isn't the same as adults. Children aren't just little adults. They're gonna be even more angry. They're gonna get sicker."

"For little kids it's scary, like being put in a closet with the lights off.

That's punishment. That's cruelty."

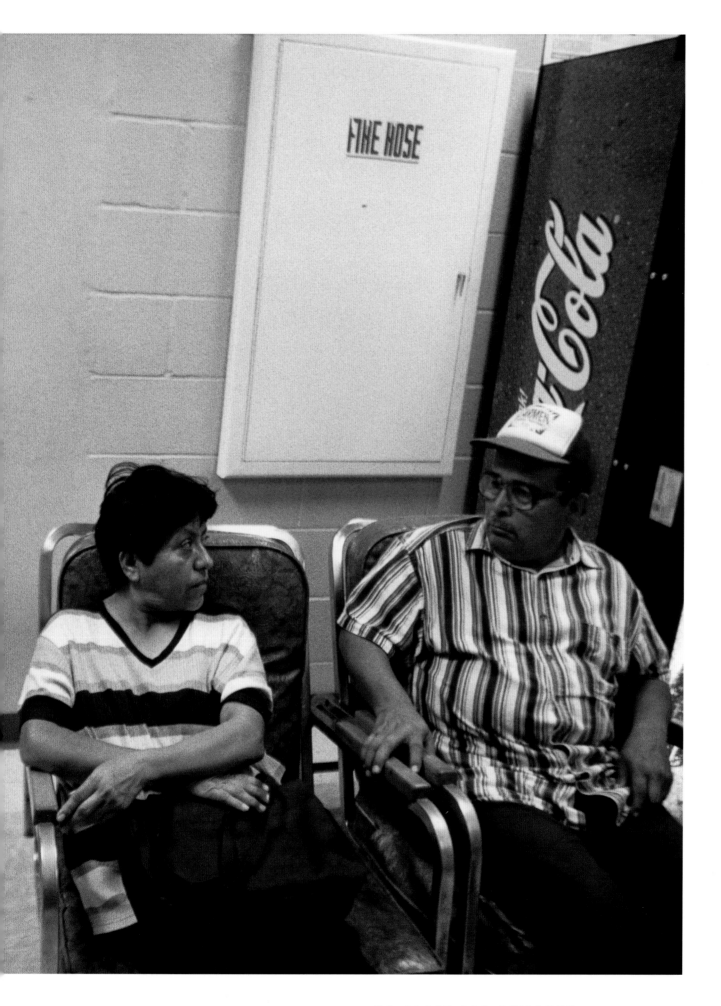

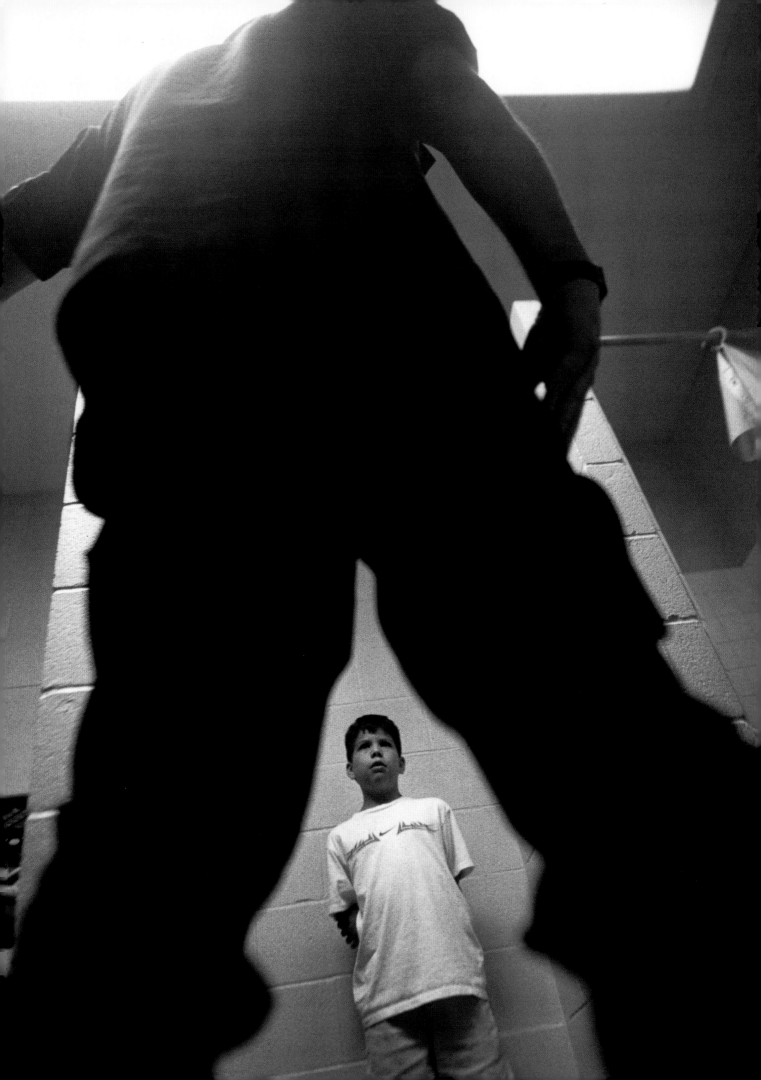

They try to scare them straight.

That's a "crisis intervention" in a nutshell.

If a child is causing trouble in school or acting up at home, parents, administrators, or the courts can send the youngster to Juvenile for an intense dose of intimidation:

SERGEANT: So why are you here?

TOMMY: Because I got in a fight.

SERGEANT: And why did you get in a fight?

TOMMY: Because a kid wouldn't leave me alone.

SERGEANT: Well, I'm not going to leave you alone in here. Are you going to fight with me? Answer me! I don't have all damn day! We are going to take you to the back, where all the big guys are. I know you have Attention Deficit Disorder, but that's not going to help you here! This is not a game! This is not a joke! Do you like it here? No? Do you like me? Do you like me?

TOMMY: Yes, sir!

SERGEANT: Don't lie to me! Do you like me? Yes or no? Tell me the damn truth!

TOMMY: No, sir.

SERGEANT: What did the boy do to pick on you?

TOMMY: He called me names.

SERGEANT: Did it hurt you? Can you feel it if I call you a name? If I call you a name, where do you feel it?

TOMMY: In my heart.

NO PLACE FOR CHILDREN

"You little brat. You've ruined everything."

A MOTHER TALKS WITH HER SON AFTER
LEARNING THAT HE WILL SPEND CHRISTMAS EVE
IN JUVENILE FOR SHOPLIFTING

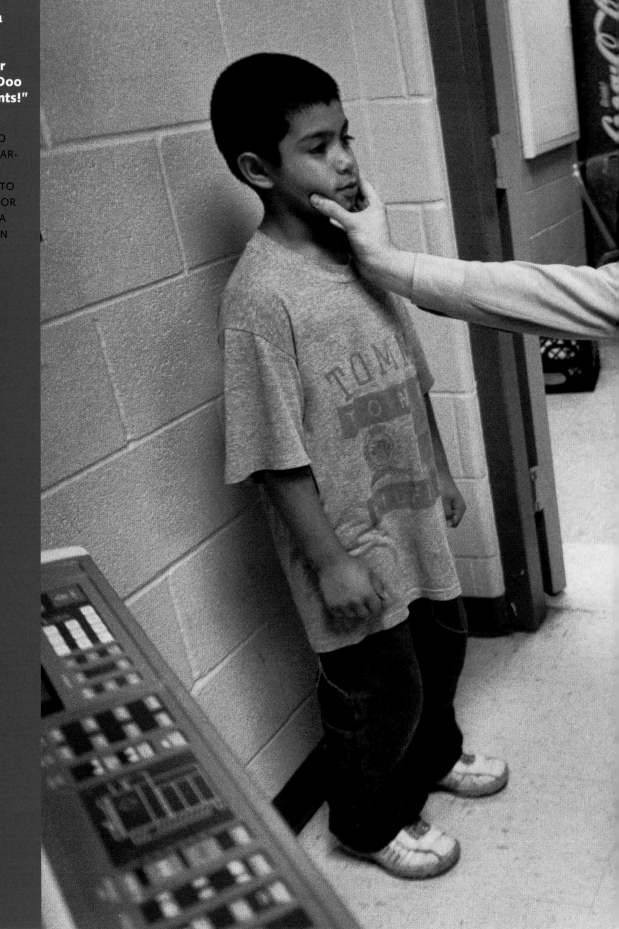

"You're a big gang member with your Scooby Doo underpants!"

JUVENILE OFFICER TO THIS 11-YEAR-OLD, WHO WAS SENT TO JUVENILE FOR MARIJUANA POSSESSION

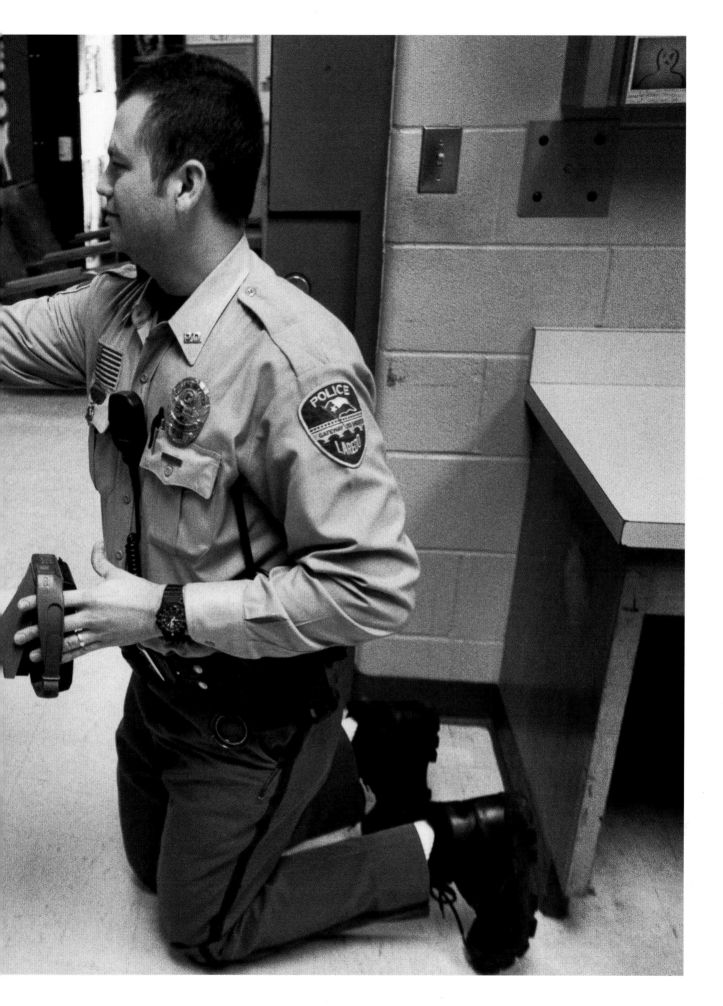

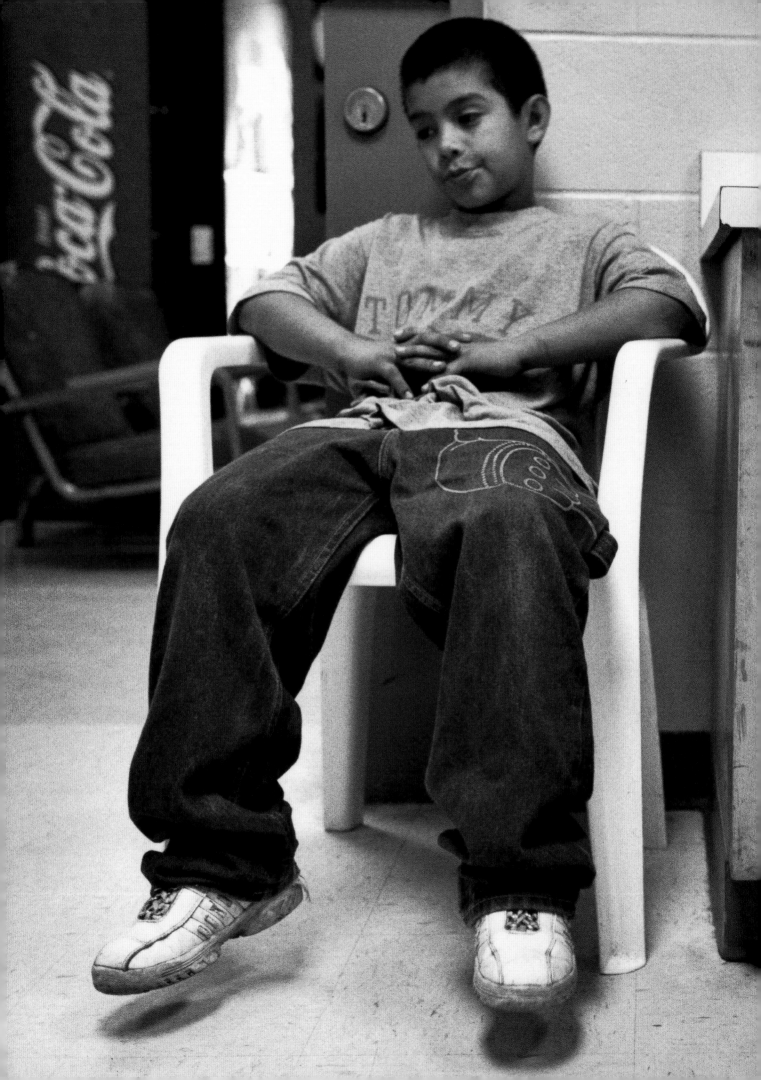

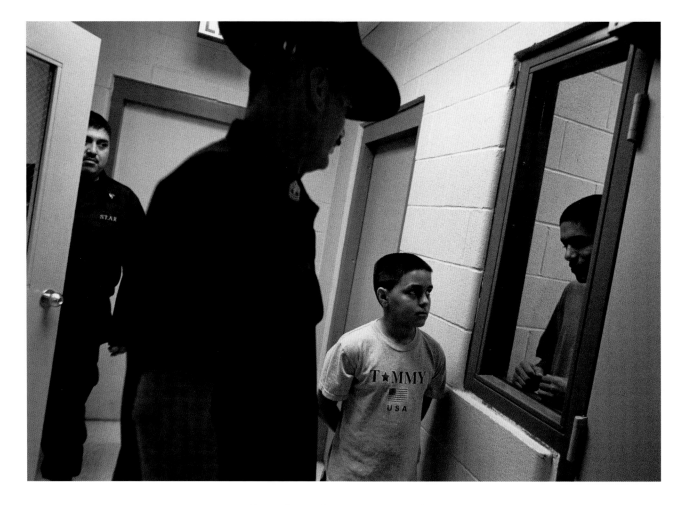

"If you keep it up, you're going to end up right here like that. It's not a pretty sight. Believe me."

SERGEANT GONZALEZ, GIVING A CRISIS INTERVENTION TOUR OF JUVENILE

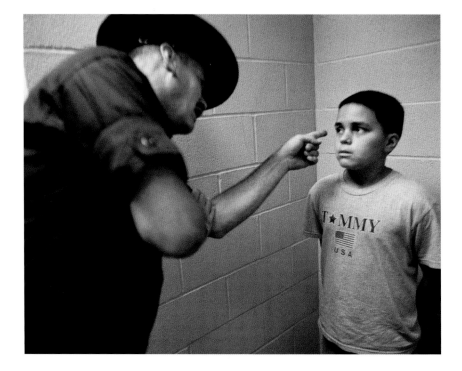

NO PLACE FOR CHILDREN

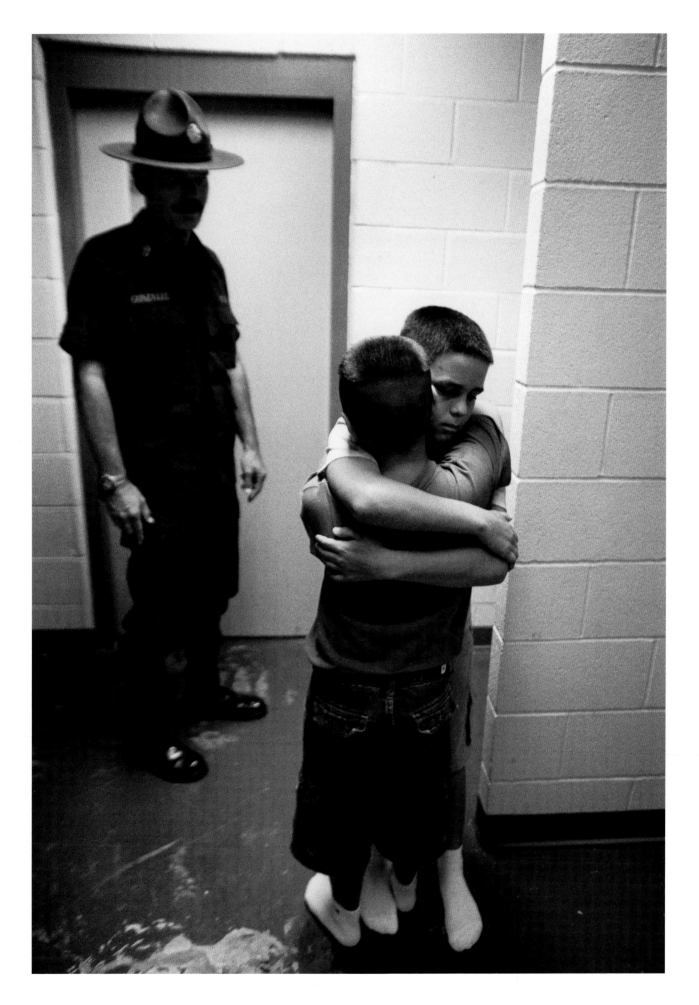

55

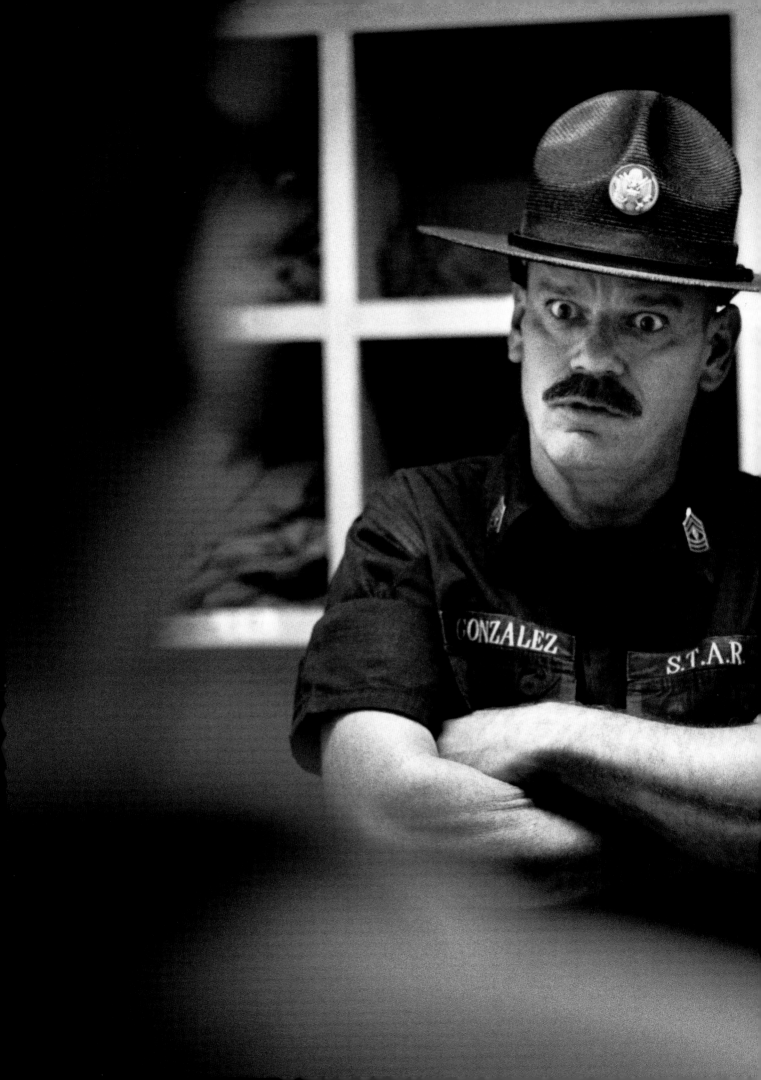

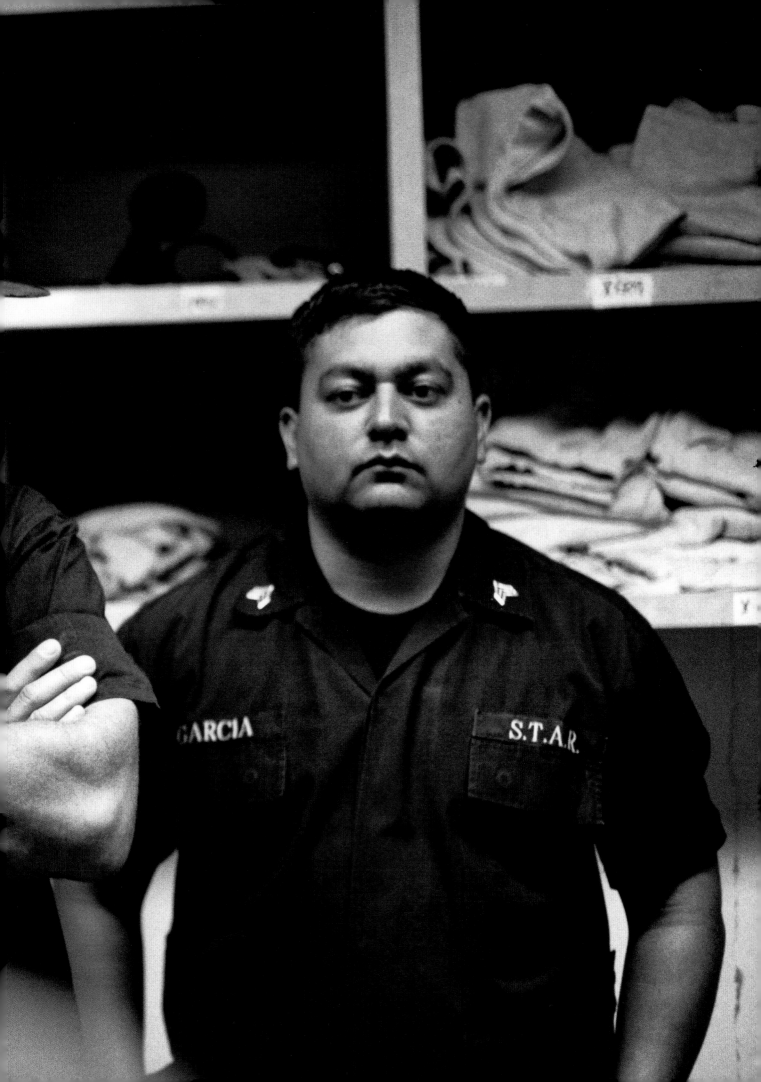

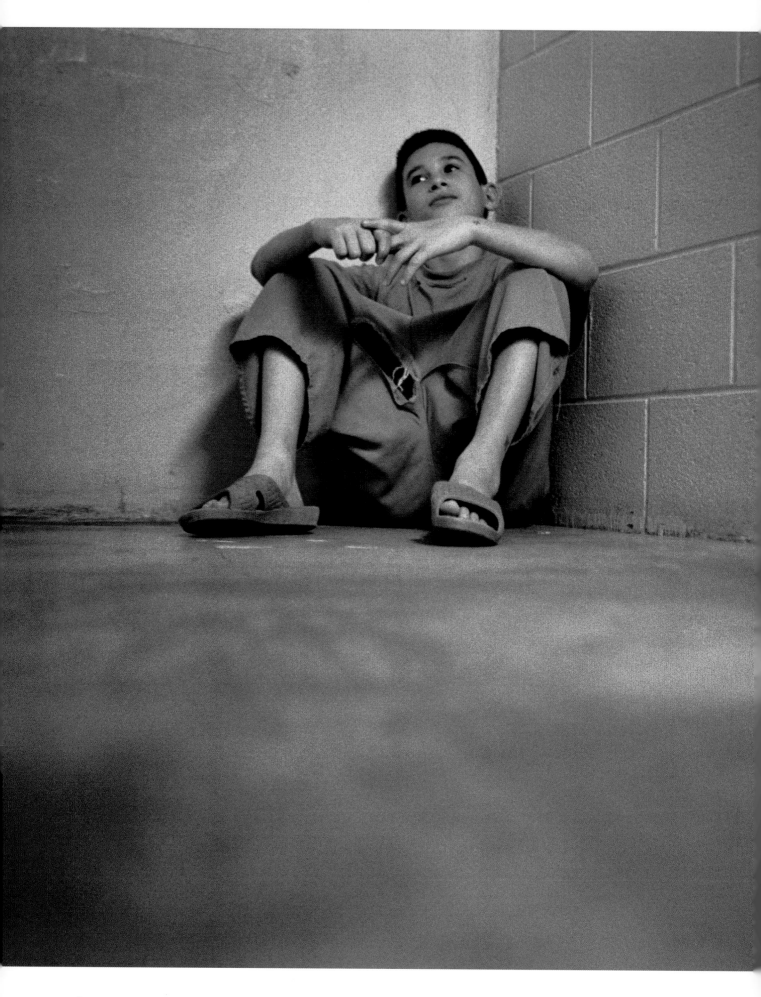

NO PLACE FOR CHILDREN

Mikey

"I was 12 years old when they first tried to shoot me."

Mikey, 13, pleaded guilty to his latest offense, threatening his mom with a knife on Thanksgiving Day. He got about 20 days in Juvenile, a place he knows well by now. And no wonder. His dad left when Mikey was in third grade, leaving his ill-prepared young mom to raise four kids alone. The household soon spun out of control, and even Mikey now laments the lack of discipline. "I wish she would have been stricter," he now says of his mom. But, like so many other solo parents, Mikey's mom didn't have the benefit of help—or hindsight.

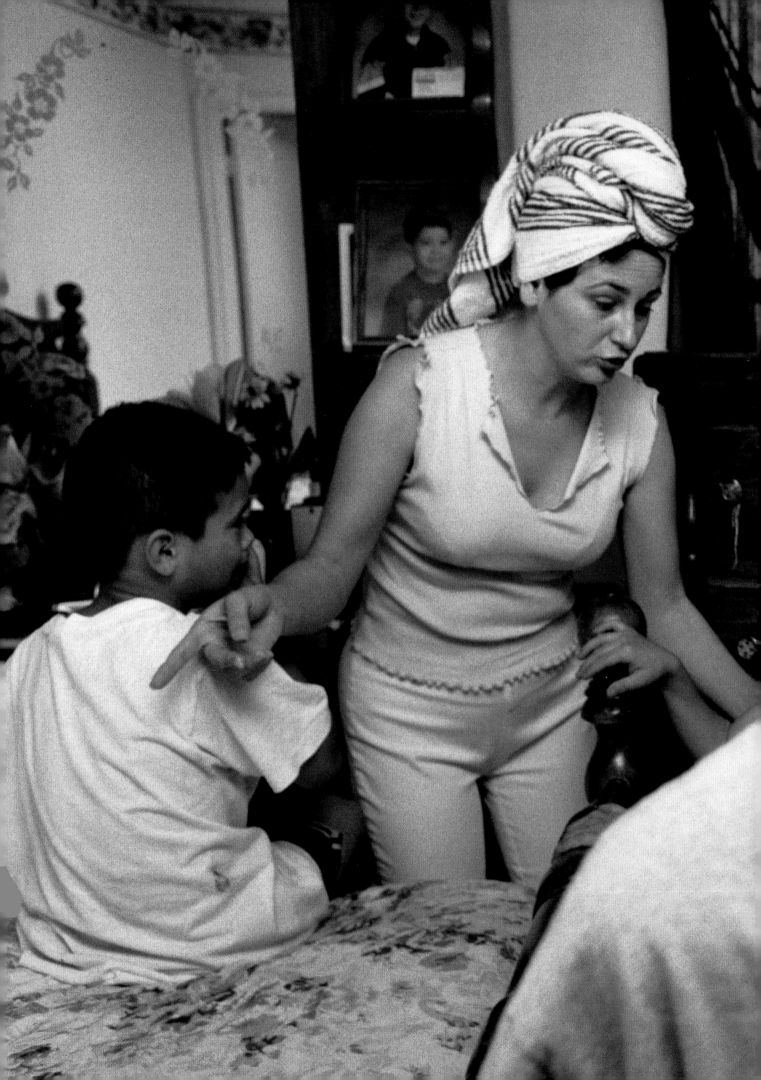

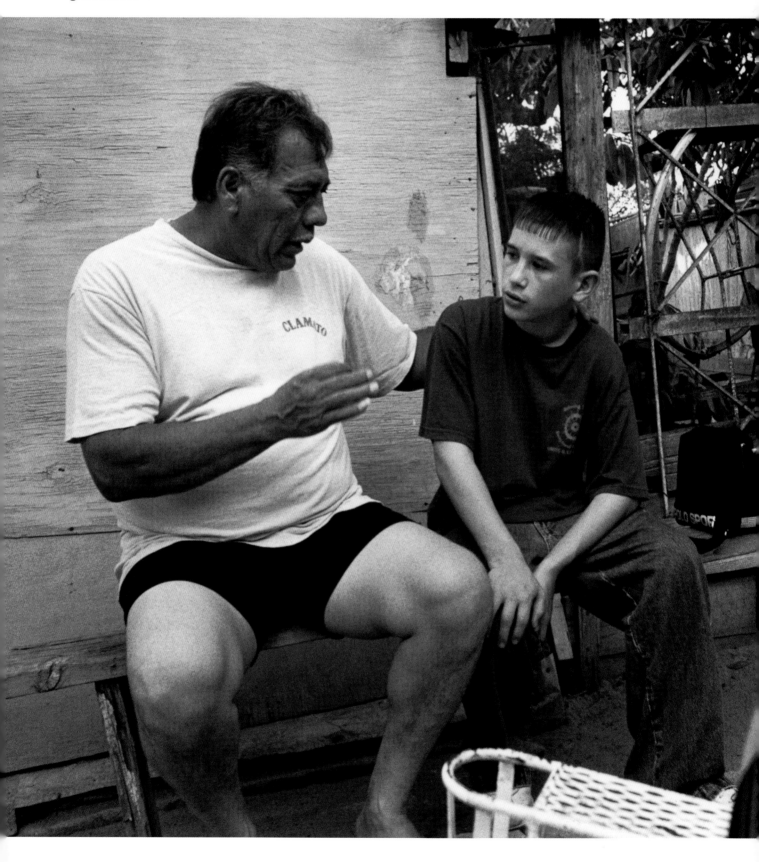

Mikey, who has grown up without a father and has been raised by his 39-year-old single mother, receives support and advice from his grandfather.

Mikey loves his hometown.

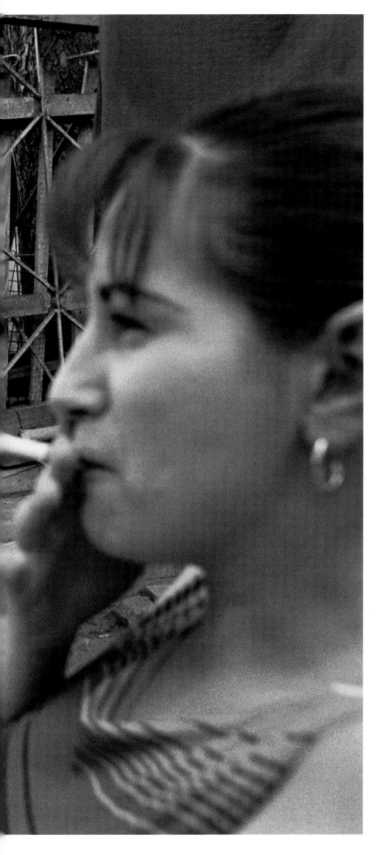

"There's a lot of drugs. There's a lot of guns."

It's a relationship that's a parent's worst nightmare. Welcome to Mikey's mom's daily struggle: competing against drugs and guns for her son's life.

It's a stiff challenge, even for veteran parents. But for Mikey's mother—a single 39-year-old raising four boys—just running her household is a challenge. Dealing with her oldest son's addictions and the violent outbursts they sometimes spawn is too much to handle. And, as Laredo probation officer Sylvia Ortegon says, parents like Mikey's mom are not getting a helping hand from the juvenile justice system:

"It costs close to $30,000 to send a kid to rehab. Most of our kids that go to rehab really try. But they're overwhelmed. We bring them back to the same environment, so it's hard for that kid to stay out of drugs, to stay away from the same group of friends. . . .

"A lot of them come from dysfunctional homes. Sometimes the parents can't even be there. We have a lot of single-parent homes where the mom has to work, maybe working two jobs.

"We have parents who love their children but sometimes feel helpless. . . . A parent will come into my office and say, 'This is my kid. He's broken. Fix him. Do something. I can no longer control his behavior. I can no longer help him.' It's hard to fix something that's been broken for years. . . .

"I've had instances where the parent sits there right next to the kid and says, 'Take him. I don't want him. I can't stand him.' Can you imagine how devastating that is to hear from your father or your mother?"

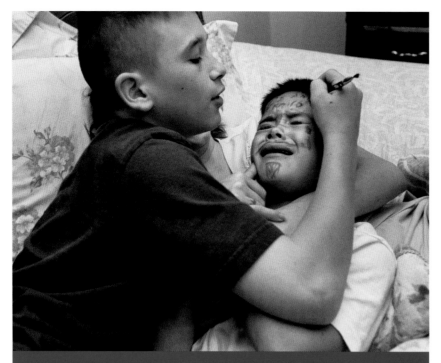

Mikey as tormentor one minute and loving big brother the next. Growing up, Mikey often got his way, a policy his mom now regrets: "I mean what I say now. If I say 'no,' it's 'no.'"

"I know my kids, and they wouldn't hurt one another. They would hit, but it's like normal siblings."

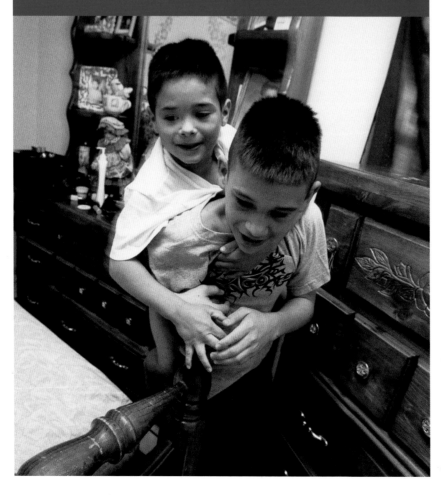

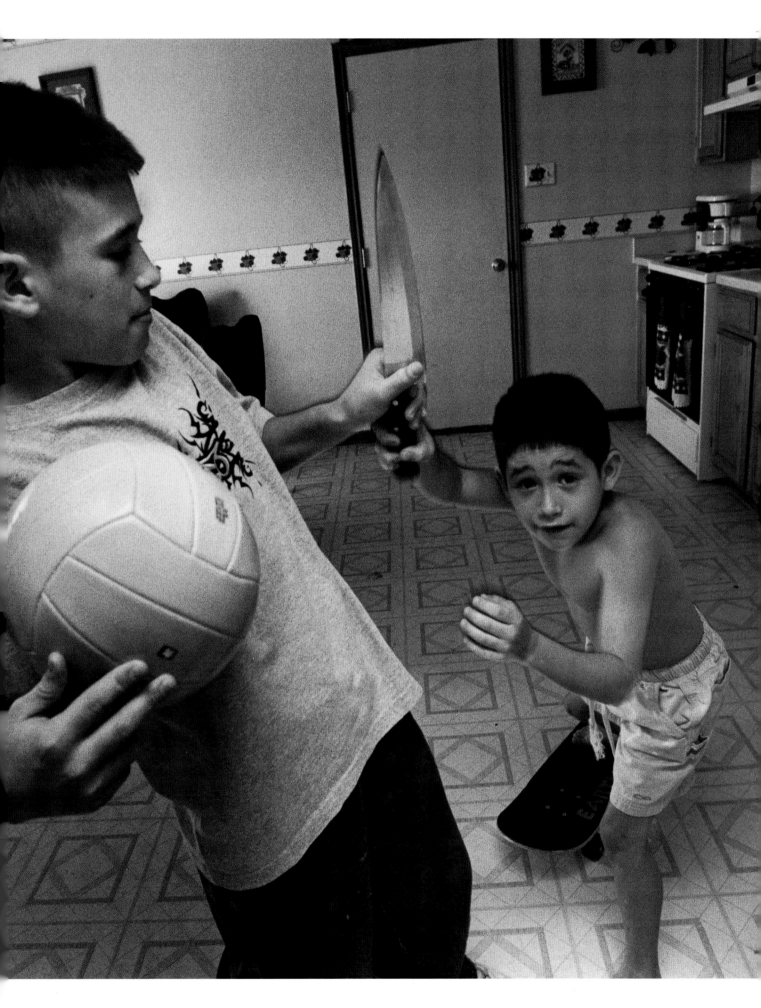

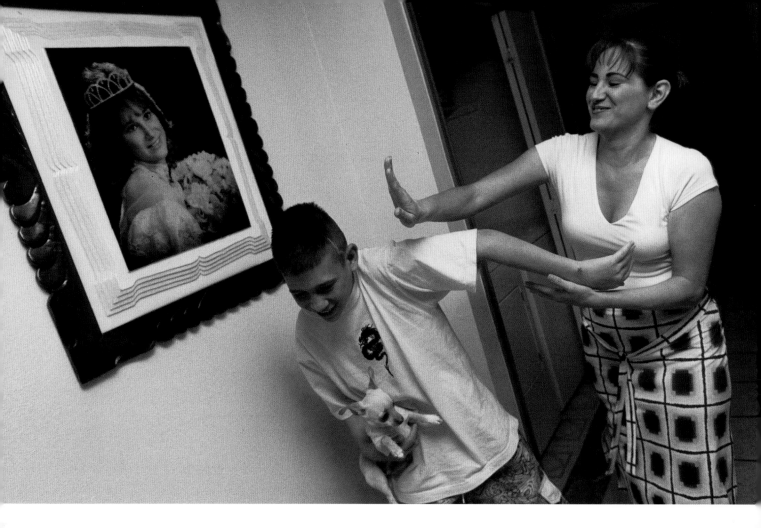

Mikey's mom teases her troubled son—and tries to restore order by "spanking" one of Mikey's younger brothers.

A conversation with Mikey and his mom

MIKEY: I've always done what I've wanted. Sometimes it was good. Remember when I was real nice?

MOM: He was wonderful. Since he was born, he was a great baby. I never had no problems with him. Never. Not even to potty train. He was a year old and he used to go to the restroom by himself.

What about not having your dad around?

MIKEY: I was in third grade when he left. That's when I started behaving badly. . . . That's when I started smoking.

Are you in touch with your dad now?

MIKEY: He's all right. I used to be mad at him, but I had reasons to be mad at him. He would do stupid shit for the drugs—to me and my brother. Like, one time he told me that he was gonna come back. He left me outside waiting for four hours. He never came back.

When Mikey first started getting sent to Juvy,
were there a lot of rules at home?

MOM: No, because I would always believe everything he said. I would always let him do things because I didn't want him to say, 'Well, I did this because you didn't let me.' He had a lot of freedom. He had too much.

Do you think your mom should have done
anything different when you were a kid?

MIKEY: I wish she would have been stricter.

Does Mikey have a curfew?

MOM: It depends where he is at. If he is at a party, he can come back like at one or two, but I call him. He even tells me, "Don't call me no more!"

MIKEY: I take the calls. I don't mind.

"I don't know what I'm doing wrong. I've already tried it so many ways. I don't know what I'm doing wrong."

MIKEY'S MOM

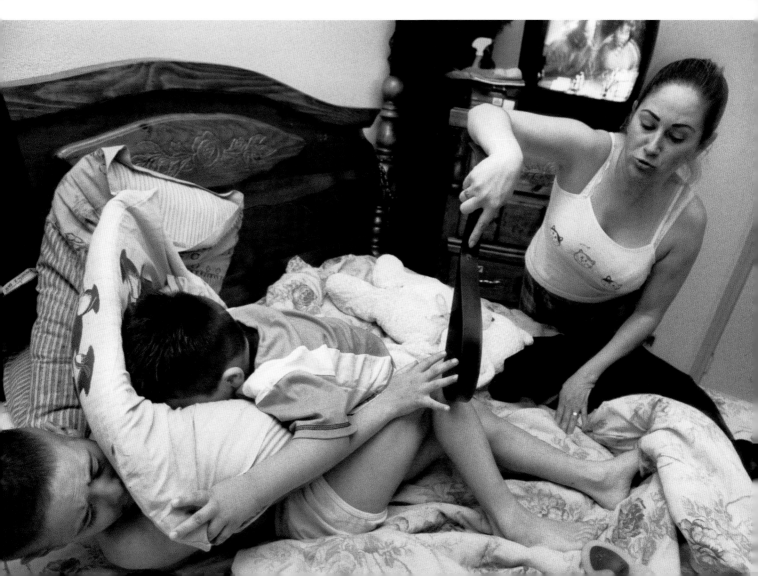

"Gangs. Gangs. A lot of gangs. That's his biggest problem. . . . I already tried everything. Nothing works. Medication, rehab. . . ."

MIKEY'S MOM

There's a possibility that Mikey is going to get sent to Texas Youth Commission.

MOM: It's the judge's decision. He has to stay clean and stay out of trouble and go to school, but he hasn't . . .

MIKEY: I have been clean and I have been going to school every day.

MOM: Well, that's not what I see. Your eyes don't get red just because they want to get red, right?

MIKEY: No, it's because I got sleep and I wake up and . . .

MOM: Oh yeah. You go to sleep out there in the truck and come back inside. And then you go out to the truck and smell like a bunch of marijuana.

MIKEY: That's the truck. That's the way it smells.

MOM: Oh, right. 'That's the truck, that's the truck.' The truck smells like marijuana now.

When's the hearing?

MOM: We don't know. They haven't told us yet. . . .

MIKEY: I'm going alone, right?

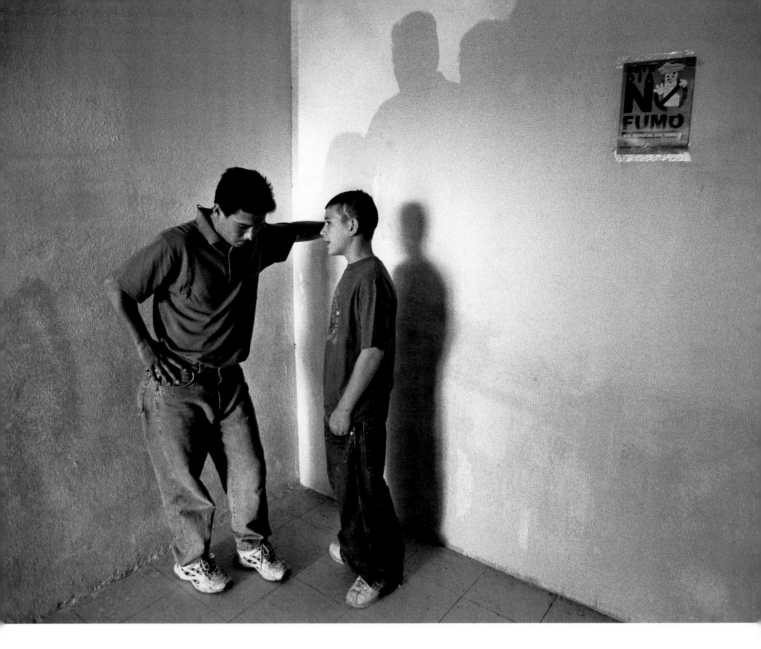

Mikey visiting his father at the Mexican jail where Dad is an inmate.

MOM: No, I'm going with you. He doesn't want me to go with him because I always tell them to drug test him.

MIKEY: I come out dirty all the time.

MOM: When he came out of rehab, he was clean for nine months. He just came out positive for cocaine one time. That's it. When probation finished, all the problems started again. . . . It was over, and then he messed up in school. He was in Juvenile for four or five days.

MIKEY: I got in a fight with a cop. He took away my ring and I decided to get it back. I did get it back—by force. They don't let you wear rings at the STEP Academy [an alternative placement for children who have violated school rules].

Does STEP work for you?

MIKEY: No. It's worse. Everybody is like me. . . . I just landed back where all of my same friends were.

MOM: Gangs. Gangs. A lot of gangs. That's his biggest problem. And the kids just wanna do whatever they want. I already tried everything. Nothing works. Medication, rehab. . . . I don't know. Maybe boot camp would help? That's my last resort. I don't think TYC would help him, anyway. It's like a penitentiary. You learn more things inside there. And I think TYC is for kids that have really, really big problems—like kill people. Those kinds. Not like for Michael. I don't think he will get to that point. I don't think so, but you never know. But being there, you pick up a lot of ideas.

MIKEY: The ideas—I already got all of them in my head.

MOM: Oh, yes! I don't say he doesn't have them. Like, I have a lot of ideas in my head too, but that doesn't mean I'm going to do it, see?

What about in Juvy? Did you pick up ideas?

MIKEY: The first time? Yeah, you pick up ideas. I was young and I grew up around all that shit, so I picked up a lot of ideas. Inside and outside of Juvy. I'm gonna change. But, I'm getting better, right?

MOM: (laughs under breath)

MIKEY: I wanna change. I'm trying to change. You get tired of being mean and bad. . . . It hurts that your mom don't talk to you. We haven't talked for like three months.

MOM: Yeah, we talk, but like I answer back very rudely because I don't really want to talk to him. I'm mad at him. I'll wash clothes and I will cook for him, but I won't have a conversation with him like I used to. I tell him off: "I don't wanna know anything about you. I don't wanna hear . . ." You see, when he's not around, we miss him a lot. He's missed! Even the kids notice when he is not around for like a day or two. "Mom, we miss Michael, Mom. We miss Michael, Mom. Where is he?"

Months after leaving rehab, Mikey sits in the front seat of his mom's car, in front of his house, and rolls a joint. "When I'm stoned, I just trip out. I see things in a nicer way, I think."

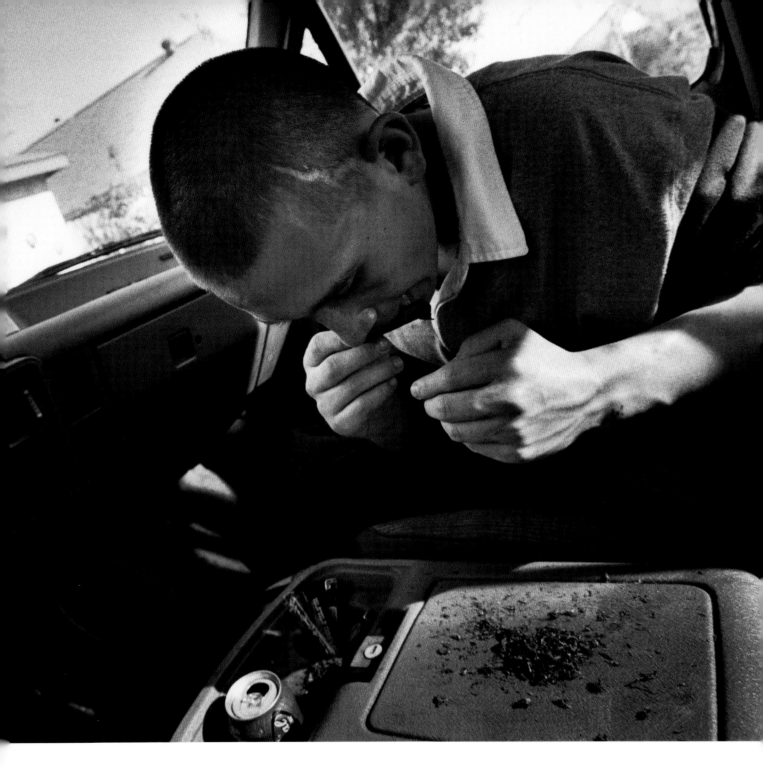

"When he is stoned, he is always laughing. And on the second day, he is in a very bad mood. See, he doesn't care. And all he talks about is he wants to be high. I don't know."

MIKEY'S MOM

How has your parenting changed?

MOM: If I say "no," it's "no." . . . I called the police two weeks ago on [Mikey]. . . . He wanted to go to the movies and I told him, "OK." But then something came up . . . and I told him, "I can't take you. I'll take you tomorrow." But no, he wanted to go like right there and then. He got all angry and started hitting the walls. I just called the police officers. I told him, "I'm not playing with you. You wanna go to jail, that's your problem, not mine."

Linda

"When I was small, 13, I put a rope around my neck and tried to jump from the fourth floor of the hospital."

She was an A student, by all accounts a normal child. But at age seven, she was sexually molested by her father. That trauma left her scared of strangers, prone to violent outbursts, and suicidal. As she grew older, her violence at home worsened; this time, at 14, she hit her mom and broke the car window. The latest outburst led to another stay in Juvenile, her fifteenth or twentieth visit.

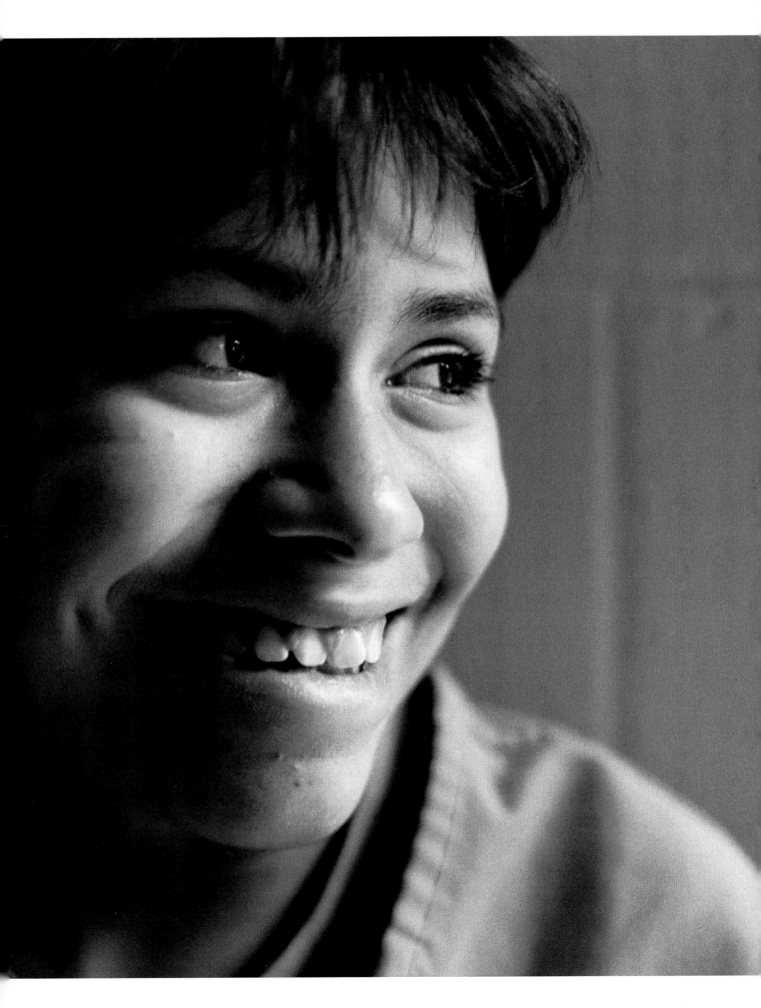

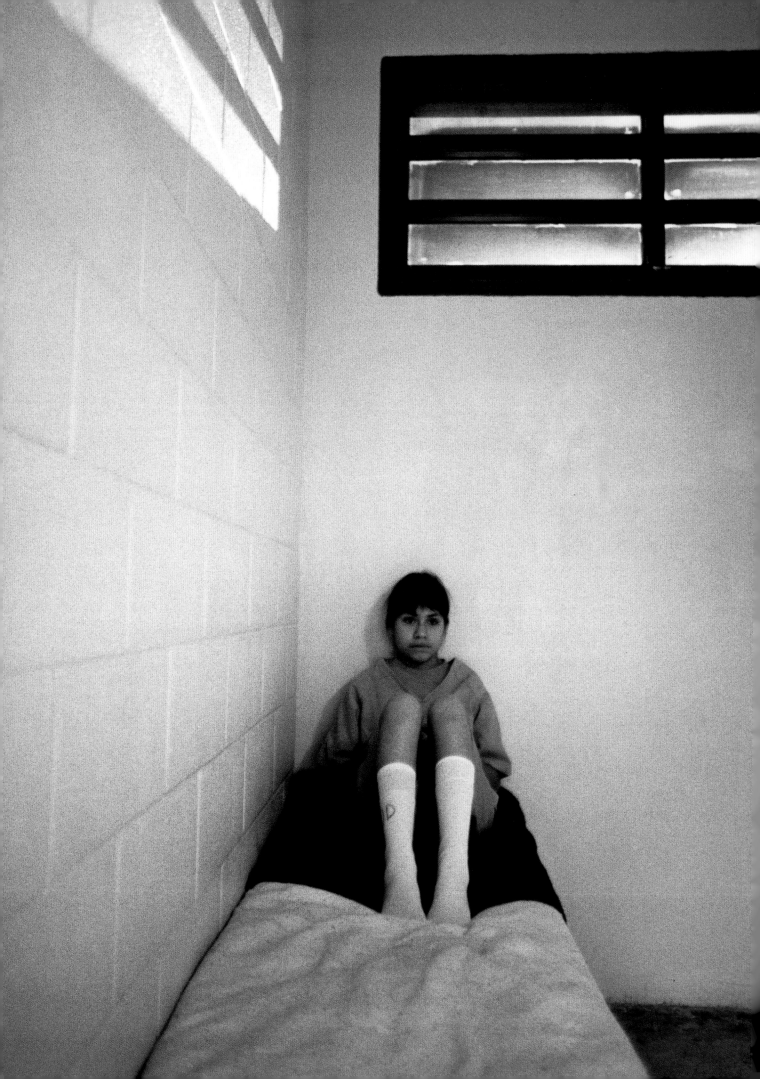

They closed the psych unit.

For Linda, that means that she will end up in a cell at Juvenile while her mental health continues to deteriorate. Probation officer Adam Rodriguez describes Linda's dilemma:

"According to the Texas Family Code, and according to some of the rehabilitation centers, she does not qualify due to the fact that she has mental health issues. San Antonio State Hospital, all these other hospitals that have psychiatric wards, won't take her because she's not extreme enough. When she comes into the detention facility there are times when she's screaming and yelling at the top of her lungs. Several guards have to restrain her and carry her into the back. By the time they call the mental health professional to get there she's calm. Because of the law, you have to have proof.

"You've got this young girl, she's got some obvious mental health issues, she's got medications that have been prescribed on a diagnosis that was probably not correct because she wouldn't participate in the psychological evaluation. So from the very beginning you have medication and diagnosis that's incorrect. You have her in the juvenile system, you have a PO that's not real sure if the child has had the right medication and diagnosis. But she's committing offences, so judicially we have to handle it. You can't place her because nobody will take her. And even the state hospital won't take her because she's not extreme enough. So she falls through the cracks.

"So what happens? She continues on probation and reports once in a while. She's in and out of the detention facility and her mom throws her hands up and says, 'They can't help me.' And it's the truth. The only time they really will offer more intense treatment is if she tries to commit suicide again.

"Unfortunately, if she commits another serious offense she's gonna fall into a judicial sanction instead of a mental health program. She'll be court-ordered to a placement or to TYC, sadly enough, as opposed to being placed somewhere where she could get better help. Unfortunately, we don't have enough of those services here in Laredo, and the ones we do have are overwhelmed.

"So what else do we do? Does she have mental health issues? Absolutely. Is she a danger to herself and others? Absolutely. Is the judicial system failing her? Absolutely. Is the mental health system failing her? Absolutely. And do I believe that a substantial number of the kids who come into our facility have mental health issues? Absolutely. We need a program educating parents about mental health issues, we need enough money to offer enough services for kids like Linda. And we need to quickly identify and appropriately help the kids who need those services."

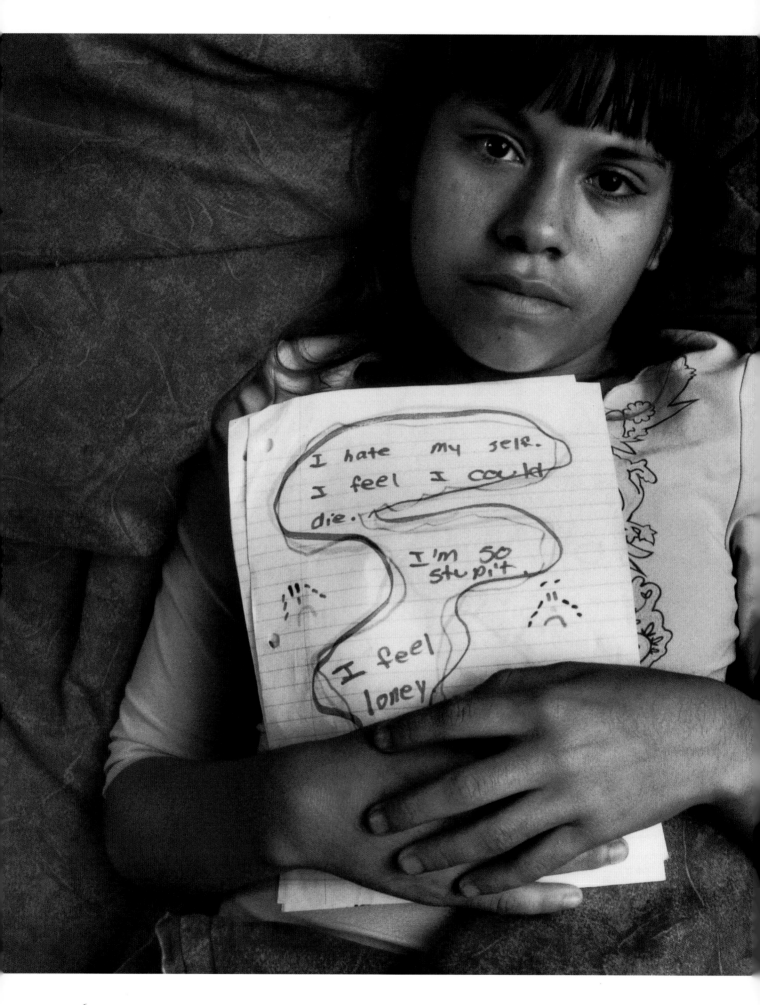

NO PLACE FOR CHILDREN

Linda's mom said Linda started behaving badly because she was molested by her father at age seven. And that's how it began. . . .

"She used to throw herself on the floor. She would roll around. She would bite herself. She used to say that she wasn't worth anything anymore. She would curse at all of us. She would say that she wanted to die—that she wanted to kill herself. She wanted to jump out the hospital window. That's when the social worker said it was too much.

"CAPS [Children and Parents Services] used to not help me. I would call them and they would tell me that Linda was not in crisis. I asked them if they were there to help me, or if they were just going to be there when the girl did more damage to herself. I told them that if they were going to wait until Linda cut herself or killed herself, then what did I need them for then? . . .

"So, she was on probation. They were going to take her to TYC, but they couldn't take her because she has "mental retardation."

"The thing that gives me the most trouble with her is that she is very violent. She hits the kids real ugly. She throws them against the walls. She has hit me before. The police has come by in the past. She has been to Juvenile a lot. She stays there for ten days.

"The truth is, I'm scared of her. I don't trust her. I wish someone would help her out long-term. She needs to be in a hospital or something. Child protective services wanted to take her away from me. They said they wanted to help me with her, but they didn't help me at all.

"They keep on sending her back to Juvenile when what she really needs is treatment—what the girl needs is treatment. She needs to be seen by a doctor. Every time she gets detained, she comes out more violent."

Gabriel

*"How I got here?
I don't remember, sir."*

Gabriel, 15, took 10 Rohypnol pills (a potent tranquilizer) and boarded the bus to school. Stoked by the drugs, an argument with another kid turned ugly. A teacher who intervened says Gabriel threatened him. When he arrived in Juvenile—his fifth time there—officers found more pills in his pocket. He is charged with "possession of a controlled substance in a correctional facility"—a felony.

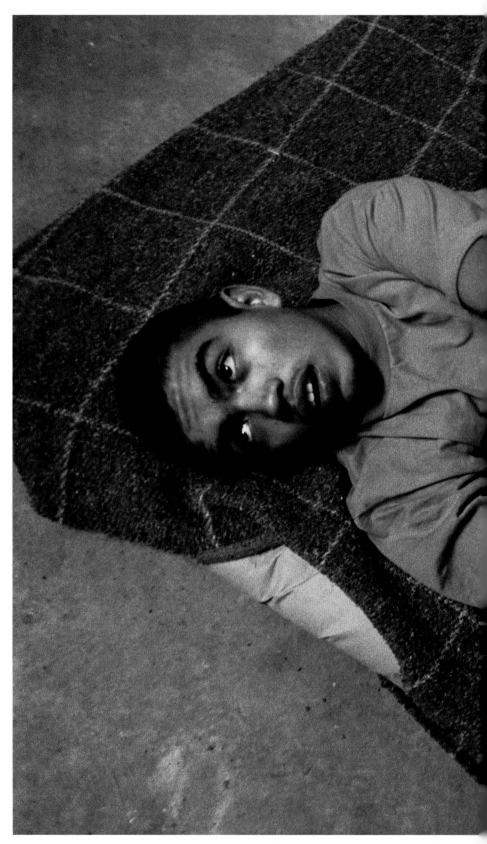

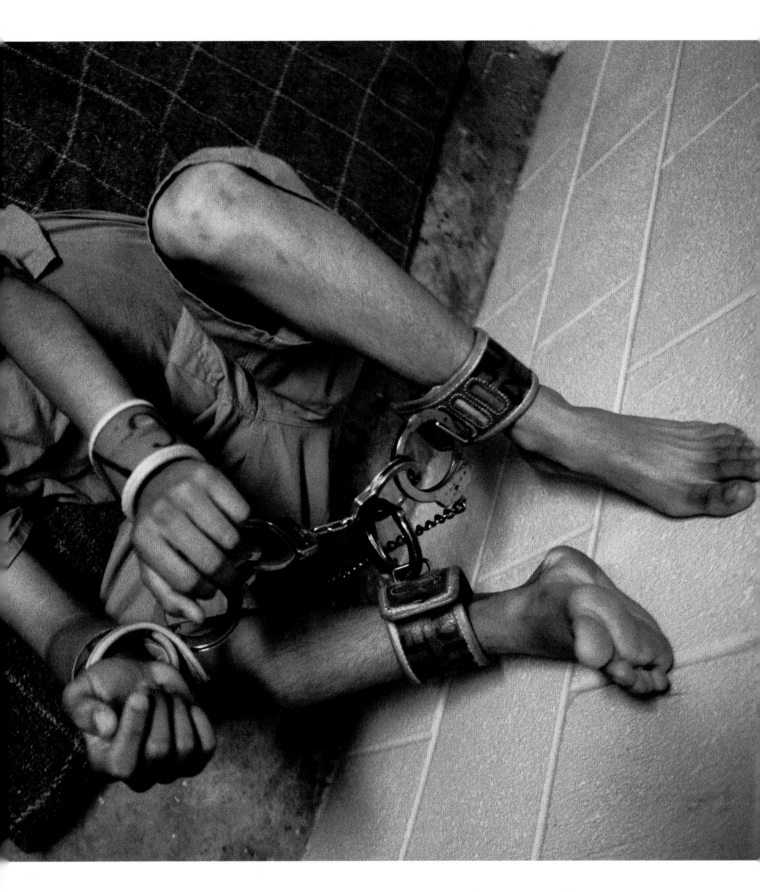

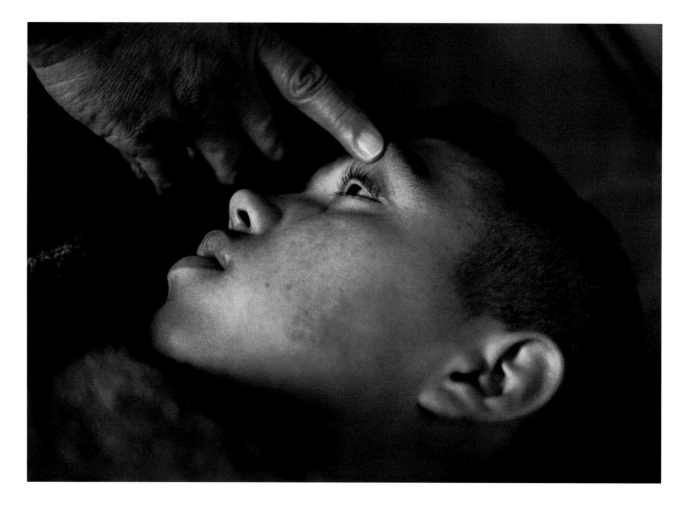

He doesn't remember how he got here.

And Gabriel isn't the only child brought to Juvenile in a narcohaze. Far from it, according to Jesse Hernandez, head of a local drug counseling program:

"Virtually everyone in the juvenile detention system is abusing drugs or is dependent. At one point, Doctor's Hospital had opened up the mental health unit and we had an adolescent detox here. In 2002 we had to give it up because it's very cost-prohibitive to run a program like that. Unfortunately, a lot of kids are now having to be detoxed in the detention center. . . .

"You never want to get in a situation where you're having to restrain people who are under the influence. It's dangerous. You may have a kid who's under the influence of inhalants. Some inhalants will make your heart beat a lot faster, and inhalants also make people get aggressive. So, you can set them up to have a cardiac arrest. That's where

a detox would come in. They'd be given medication, fluids to hydrate them, a bed where they could sleep, their vitals would be taken every 20 minutes. They'd be attended to.

"If you think about it, this is their first experience in treatment for these kids. If they have a good first experience, then they're gonna be more likely to follow up in other services. However, if their first experience in withdrawal is just a lot of physical and emotional pain, they're gonna continue to avoid it. And how do they do that? They just keep on using drugs.

"Eventually, kids get to the point when they're using these drugs that they're acting out so much you can't have them in school. But the juvenile detention isn't really set up to deal with the multiple issues most of these children come in with. They don't have the staff at the juvenile to do that. These kids aren't dogs, they're human beings. But for the grace of God that could be anybody's child. It could have been me."

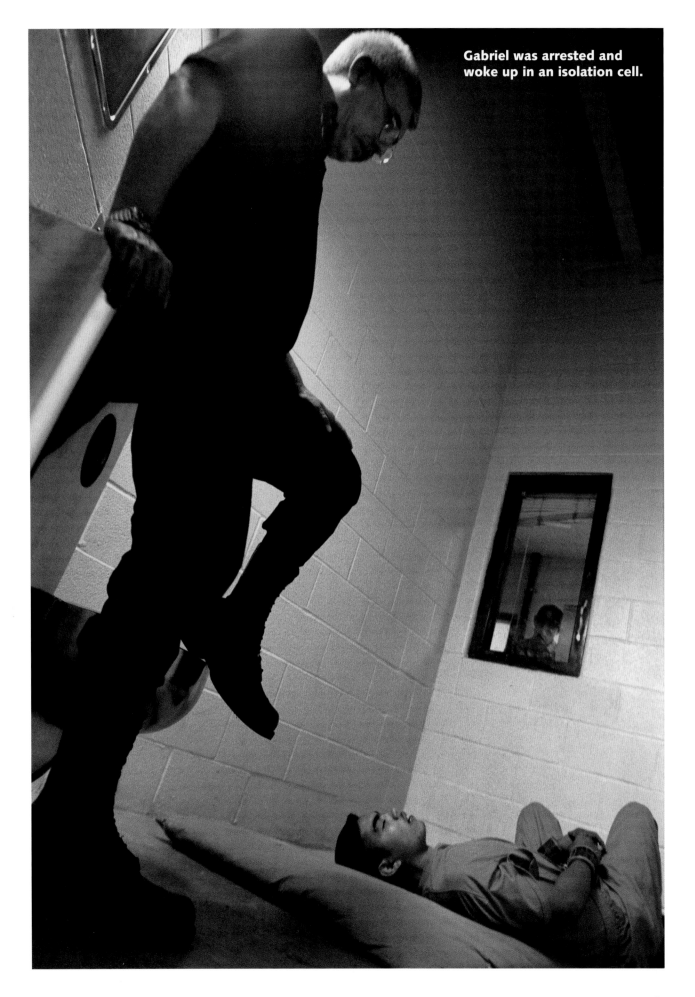

Gabriel was arrested and woke up in an isolation cell.

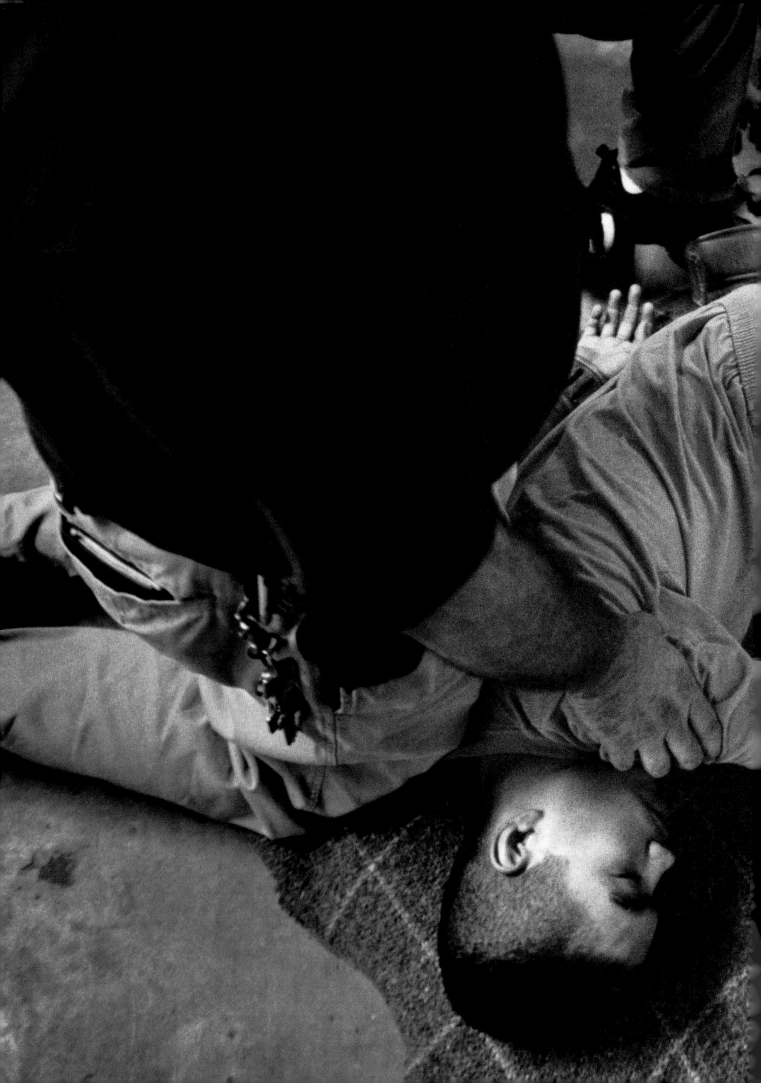

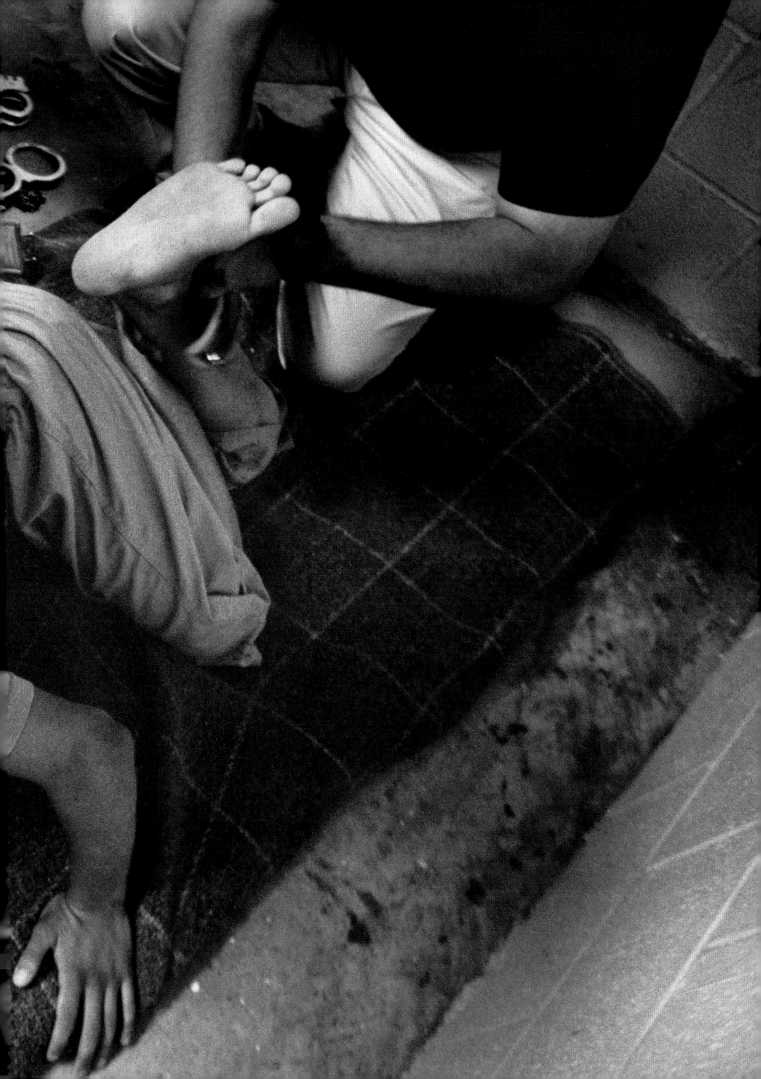

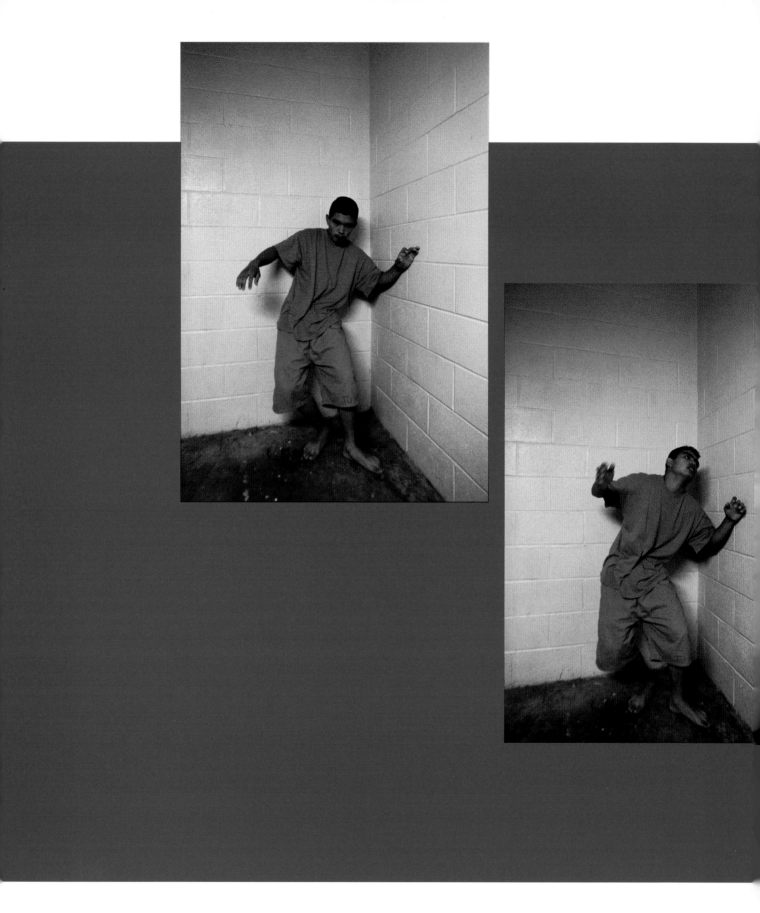

NO PLACE FOR CHILDREN

On his second day in Juvenile,
Gabriel is still detoxing when he has
a high-volume exchange with a guard:

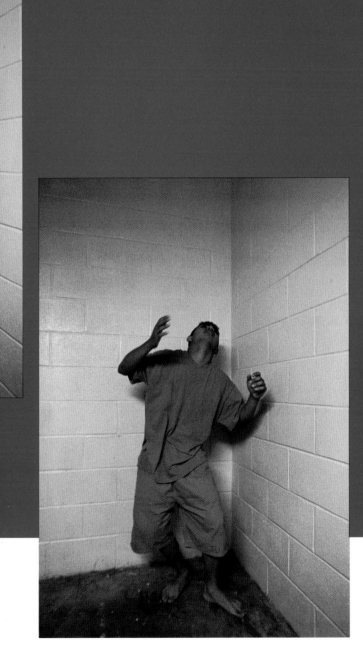

GUARD: Gabriel, I came to talk to you.

GABRIEL: I don't even know why I'm locked up.

GUARD: You took too many pills, and we had to restrain you because you wanted to kill me.

GABRIEL: You just want to keep me locked up all day and I didn't even do anything. I swear I won't hurt anyone, but I just want to get out of here already.

GUARD: No. No, I can't take you out. You just want to hurt me. Do you think I'm happy having to do this to you?

GABRIEL: Damn it, will you just take these things off then? Just take them off! Look at how I have my fucking hands! They burn already. Because these things are too tight! They are too tight. Please, sir! I can't stand it. Sir, please, sir! Please! I want to talk to my mom! She doesn't know that I'm here! I want to see my fucking baby girl! Please! . . .

GUARD: Your mom already knows you are here.

GABRIEL: She doesn't know! I know my mom! If she knew I was in here she would be here—snap—like that! . . . How can you expect me to calm down? I can't stand on my fucking feet, man!

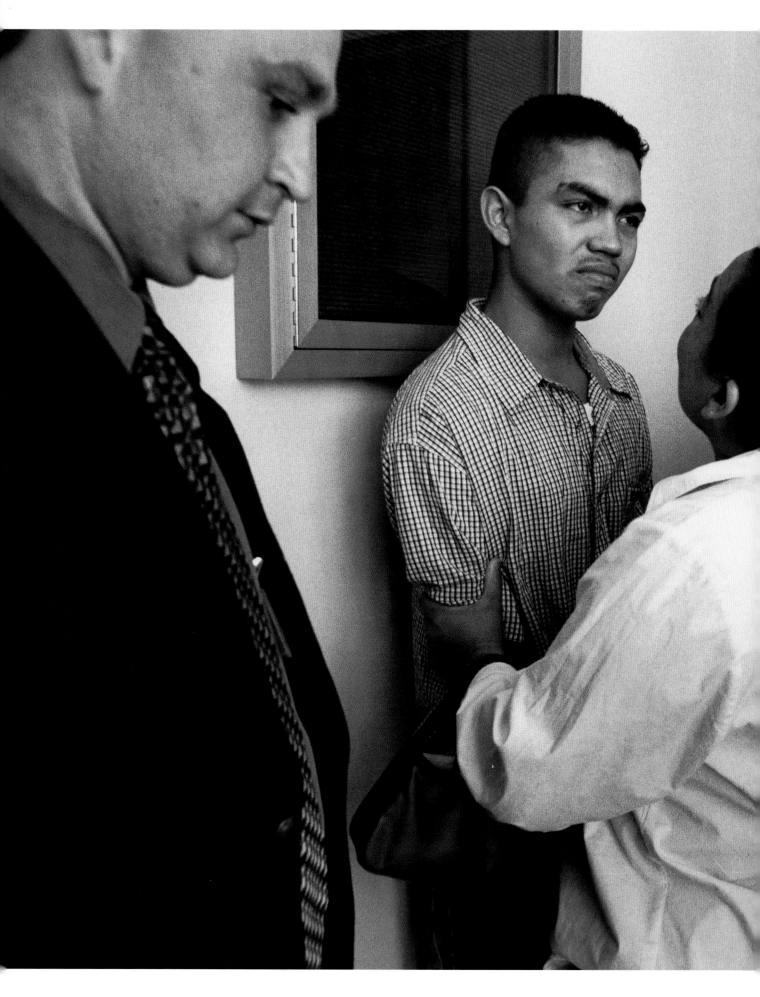

NO PLACE FOR CHILDREN

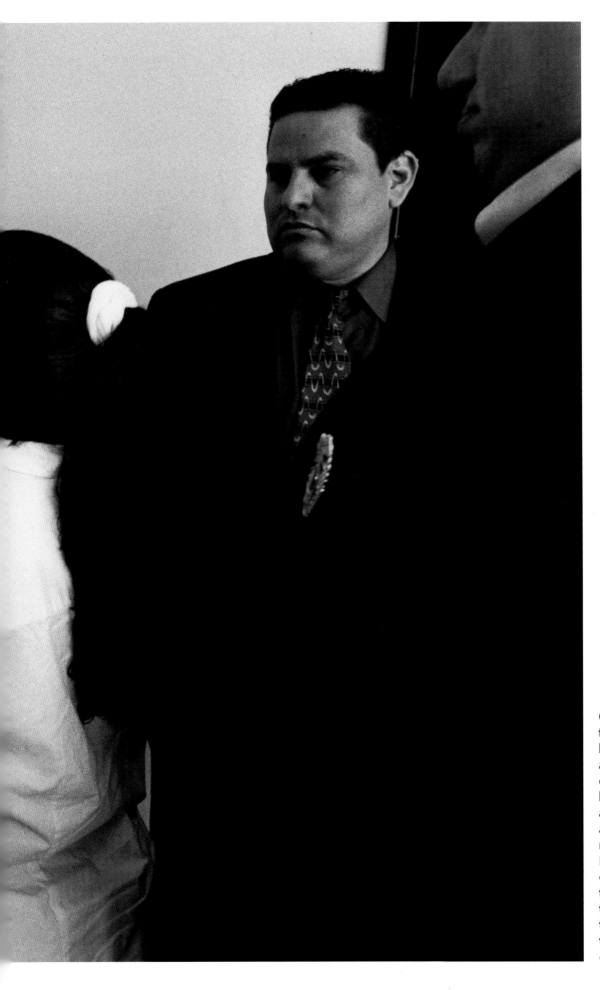

Gabriel
talks with
his mother
after a judge
cancelled
his court
appearance
at the last
minute.
Probation
officers told
the judge
that he was
too rowdy
to appear in
court.

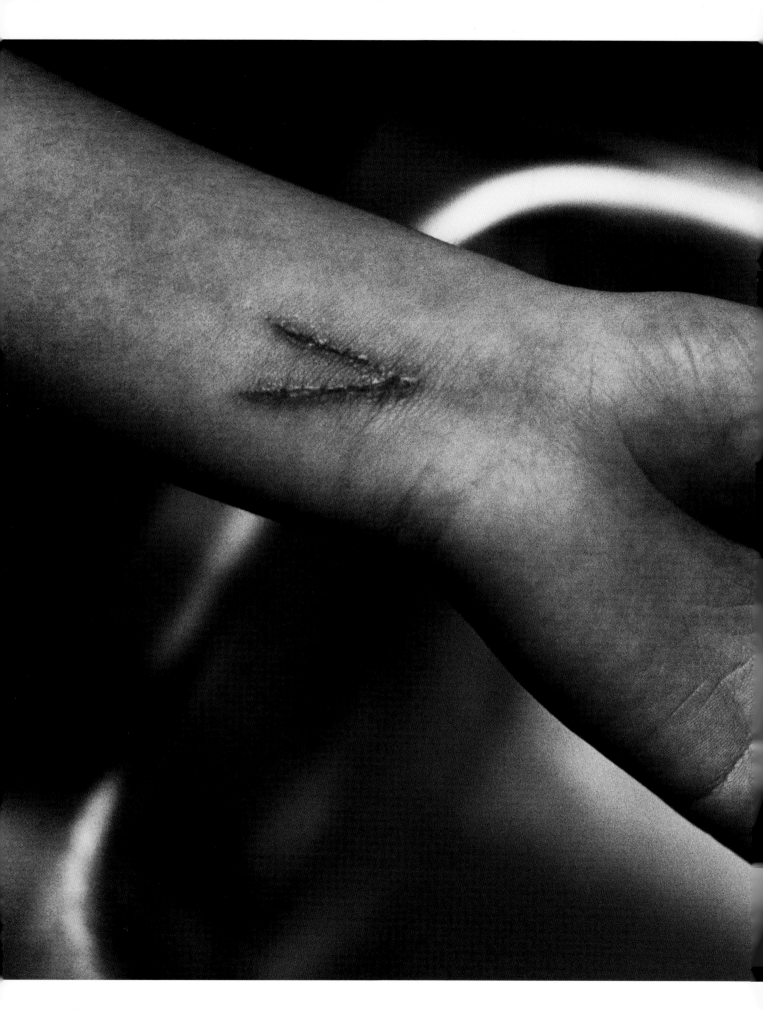

NO PLACE FOR CHILDREN

Zulema

Her knife was her ticket out.

Zulema wanted to escape from a world filled with problems. First, she turned to pills. Then came marijuana and now crack cocaine:

"When I do drugs it makes me forget about my problems: family problems, friend problems, boyfriend problems. I started drinking, and then I went to pills and then to marijuana, and now I'm on crack cocaine. And the worst part is when you're not drugged anymore, you're back to reality. I tried before, quitting drugs, but I can't stop.

"I just give problems to my parents and they're nice people. Like this past time, I just . . .

"I was doing cocaine and took some pills and I thought I was gonna die. . . . I wanted to die. And I was scared 'cause . . . I dunno, I got mad at my mom and we were fighting and I went to my room and I tried to cut my veins with my knife.

"I wish it would have worked."

NO PLACE FOR CHILDREN

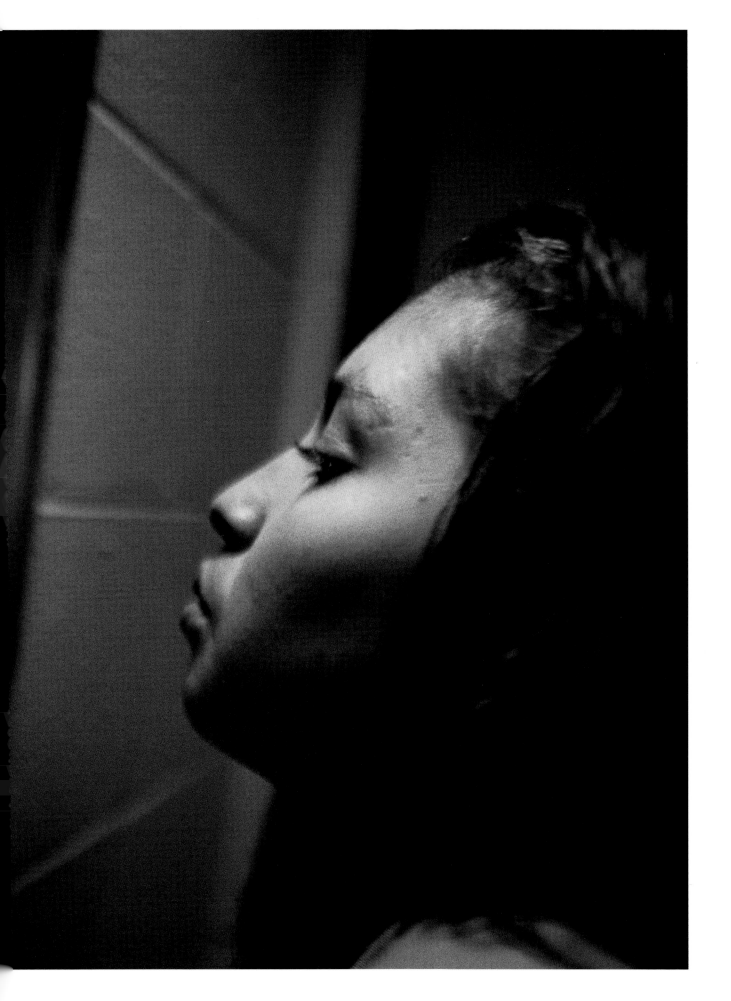

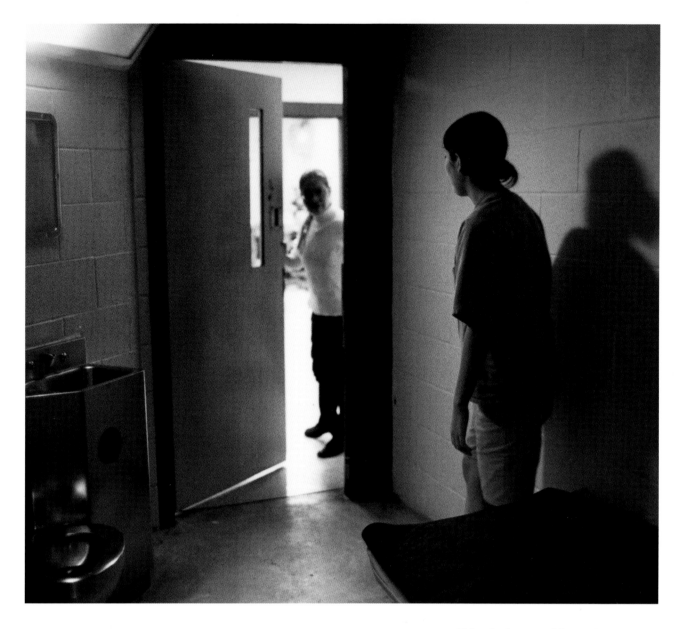

"I just give problems to my parents and they're nice people. . . . I was doing cocaine and took some pills. . . . I wanted to die. . . ."

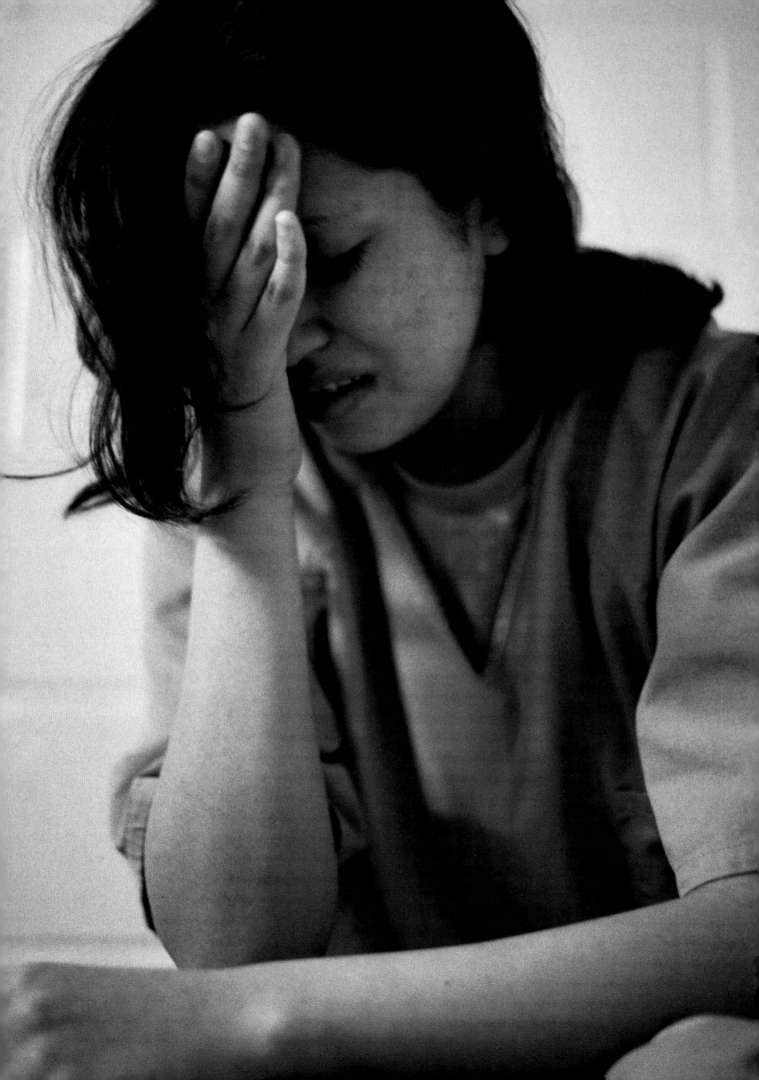

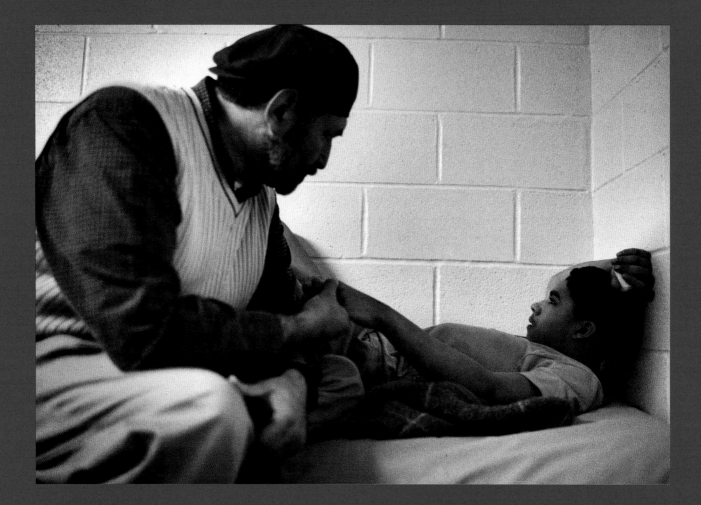

THE OFFICERS

They are the triage doctors of the justice system, treating the kids that others—the parents, the teachers, the social workers—can't or won't help. Juvenile is where these kids go, and Juvenile is where detention and probation officers go when they head to the office. Some are dedicated above and beyond the call of duty; others merely show up and do the minimum; a few, to put it bluntly, aren't very good at their jobs. In short, it sounds like an average office. But for the officers who really care, the dedication required to help mend some of our most fractured and fragile citizens is far from average.

Adam

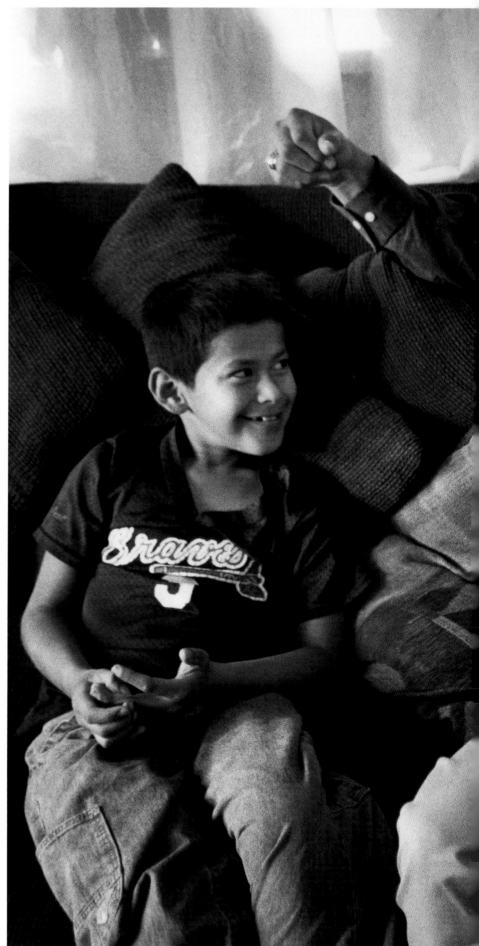

"We're the surrogate father, the teacher, the preacher, the big brother or sister, the friend they never had."

Adam Rodriguez, 35, has been a juvenile probation officer for three years. He knows he has a lot of power over young lives—and a lot of responsibility. "From the start—from the first time you sit down in the pod with that child—you have to say, 'You know what? You messed up, but it's OK. We're gonna get through this. Let's see what we can do to change this.'"

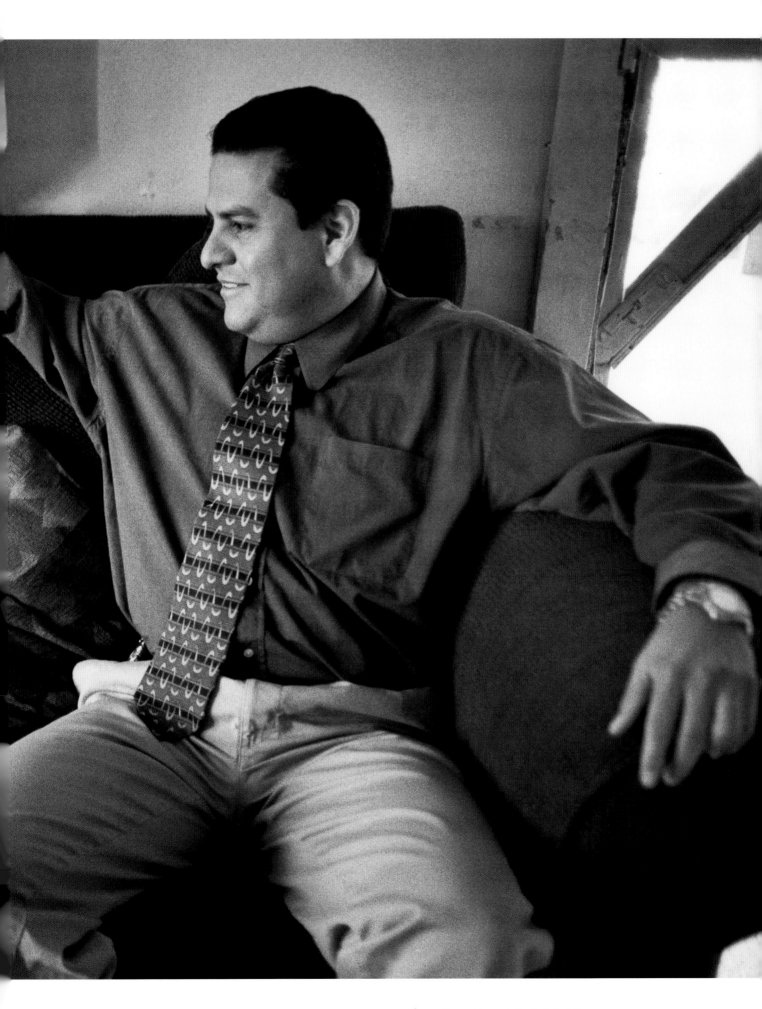

It's supposed to be about rehabilitation.

That's the goal of the juvenile system, according to Adam Rodriguez. But making that goal a reality depends on the commitment of Adam, his fellow probation officers, and the rest of the system to helping turn kids around—a commitment that is often lacking. He explains:

"How do you expect kids to succeed if you don't offer them services? Miss Campos, my supervisor, audited quite a few files—I'm talking over a hundred files—randomly, and found that the vast majority of POs didn't refer their kids to services. One child had been placed on probation for an entire year and the PO hadn't seen the child once. Not once. For a whole year. The case was closed and two weeks later the child committed an aggravated robbery—felony one. If you've already labeled that child then he's not going to succeed. And then we fail the kid. The child suffers and the community suffers because these kids come back into our society and continue criminal behavior."

Adam feels that, even in the hands of the most dedicated POs, many kids are doomed by a flawed system: "I personally believe that there should be a pre-trial facility that's not quite like ours, especially for kids that are first-timers. Kids ages 10 to 13 are still so young and so easily influenced by older kids. It's a huge injustice mixing the age groups up. Today, coming back from court, we had a 13-year-old sitting next to a kid charged with murder. And they're sitting there and they're talking about his case. So what's he telling him? 'Yeah, I shot this kid. We chased him in the house. . . .' He glamorizes what he did. How do you think that's gonna affect a 12- or 13-year-old? He is a child. A kid that age should be riding his bike, he should be playing Xbox, doing his homework. He should not be sitting in a facility hearing about how someone chased someone else into a house and shot him with a .45.

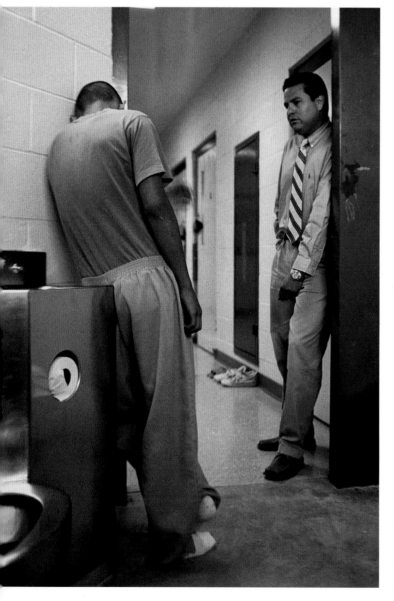

"So what are you gonna do with these kids? I think the intake department should be able to make a decision as to whether or not these kids should go to other services. There should be a shelter, and a medium-risk detention facility where a social

worker along with a PO would meet with the parent. It would be less like a jail, so the experience is not quite so traumatic. Right now, the only option for intake officers is release or detain. If the child's released, he's spared from this traumatic experience, but he may go back to the streets. If he's detained, he goes in the back with three other kids who've committed capital murders, four other kids with felony charges who are all TYC commitments—but he's just shoplifted at Foley's. So, all of a sudden, you have the kids that are first-timers being trained by multiple offenders. And 10 days later you release this kid and he's learned how to pack a .45 and do a drive-by. They learn how to hide, they learn how to smuggle, they learn how to sell."

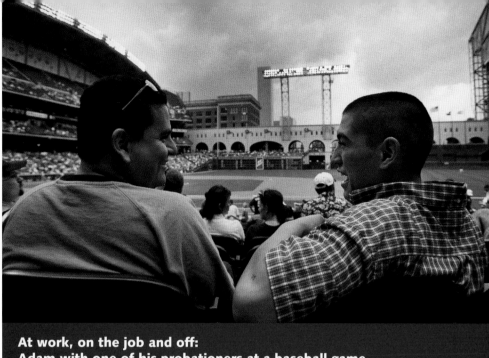

**At work, on the job and off:
Adam with one of his probationers at a baseball game.**

And then there are the flawed laws:

"I would say that maybe 30 percent of the kids we have are clearly criminals, kids that are there because they want to be there. The other 70 percent are there because of drugs or mental health issues. I would say that 95 percent of the kids that come into our department are clinically depressed. If you ask them 'What's wrong with you?,' they'll say 'I'm depressed' or 'I'm angry' or both. Bottom line: they're self-medicating. And, since the law changed in 1996, a lot of the behavior that we ourselves used to do as kids has been criminalized. A lot of this conduct is stuff you'd expect from kids. Kids are gonna get in fights. Kids are gonna break things.

"When I was about 10 years old, a friend and I were throwing rocks at some parked 18-wheelers and we broke the window in the front of one of them. I'll never forget: the sheriff picked us up and took us in and my parents had to pick me up. If that happened today, it would be a state-jail felony. I would have been placed on probation. I would have had a record. I wouldn't have been able to get this job I have today. I would have been a criminal. . . .

"Do you think it's fair for a child to be charged with a 'terroristic threat' because he pointed his finger at a teacher? Twenty percent of our referrals are unnecessary. Easy. Twenty percent. We're overwhelmed. In Texas, each probation officer is supposed to have between 40 and 60 kids. For a long period of time, I had over 75 kids. At one point, I had 96."

Ultimately, Adam knows it is up to the public to change this failed approach to juvenile crime—or to continue to ignore it:

"We're called the 'bastard department' because, for some reason, juveniles just aren't considered important. Remember, it's about the almighty buck. For the public you have to put a dollar amount on it. We can either let a kid become part of the criminal justice system, where it costs $42,000 per year to incarcerate the kid at the Texas Youth Commission, or we can help him go to a good college for $24,000 per year. We decide. Kids are a good investment; they really are."

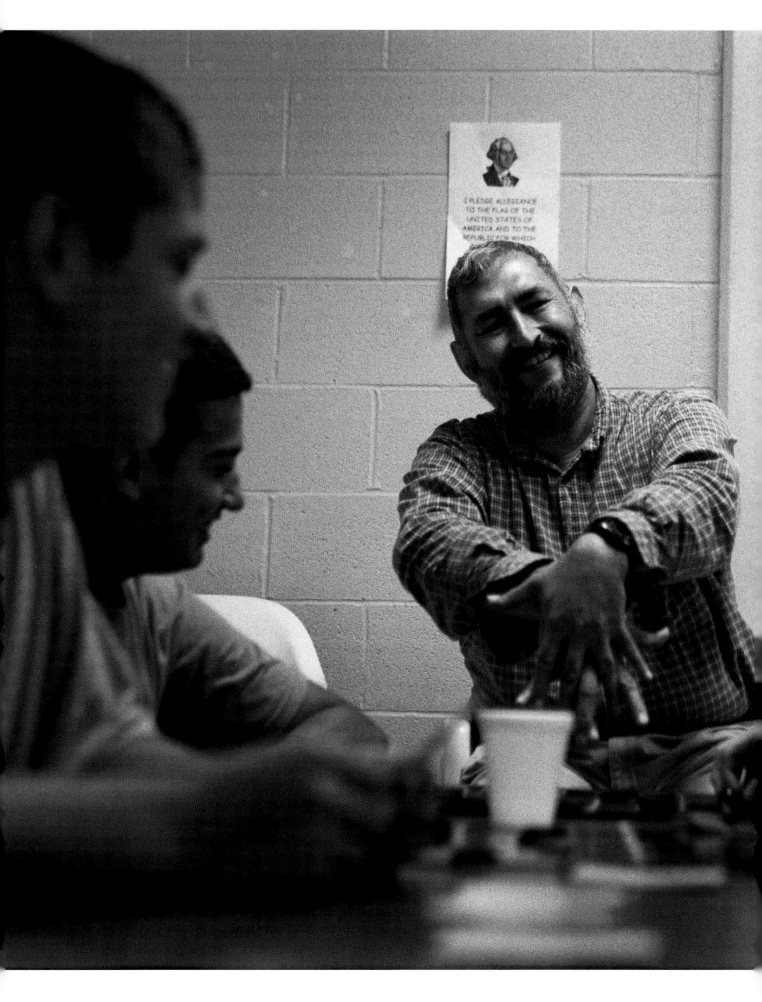

Leo

"We all have to wear multiple hats and to change them within seconds."

On detention officer Leo De La Garza's first day of work in 1980, his instructions were simple: "They told me, 'Here are the keys, there are the kids. If anything happens, just whack 'em.'" The approach to inmates has softened over the years. Now, Leo, 50, tells his kids, "Hey, you are somebody important to us and you can actually change if you want to."

He sees the same kids over and over again.

That's the frustrating reality of Leo De La Garza's job. He does his best to help kids in Juvenile, but Leo knows that there are better ways to help them. The revolving door system is sadly predictable, he says:

"I've heard it from the kids themselves: 'OK, so they put me on probation. So what? I call in my PO. I show up to report once a month or maybe once a week. *Mi vida loca*—it's my crazy life, and I'm gonna do what I want with it. If I'm gonna die, I'm gonna die—*ya me toca.*'

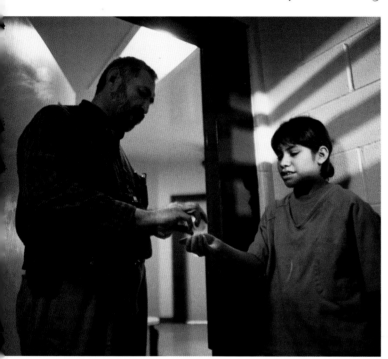

"In detention, we see the same kids over and over again. It hurts when you're working as a detention officer and you see what's going on. I shouldn't take this personally, but I do. Every time I read about a kid who OD'd it hurts because it's like I was there. How many of these kids can we actually help? How many success stories have there been where I can say we really were able to make a difference? I could probably just count them with the fingers of my right hand. You watch some beautiful lives just get wasted. . . .

Dispensing medicine to Linda. Leo adapts his approach to the child and the situation; sometimes he can be a strict disciplinarian, more often he's patient and fatherly.

"The ones that I really say, 'Man, they should be placed somewhere else,' are the runaways. The community should provide more halfway houses for runaways, provide shelter for them. We've had parents of runaways who say, 'Hey, I've already had it with him or her. It's your turn to discipline them.'

"The peer pressure on these kids is tremendous, and most of them don't really have a structure or foundation to follow or to fall back on. Some of their parents are doing time in jail. We have cases where Mom is working as a prostitute to bring in the money. So the kids see it as part of the cycle of life: 'My father did it, my grandfather did it.'

"One of the saddest things I remember is this 10-year-old kid. It was Christmas Eve, and we only had him in detention. I called my supervisor and got permission to release the boy to his mother. But when I called his mother, she said, 'No, I don't have the time to go and pick him up right now, and I really don't want to.' And you could hear the laughter and the humongous party that was going on over the phone. And she just hung up. And I walked over and the kid was sitting on his bed and you could see the tears and he just looked at me and said, 'Do you think she loves me?' And I said 'Who?' and he said 'My mother.' And I said, 'All mothers love their kids regardless of what happens.' And he asked if I'd be there and I told him, 'Of course I'm gonna be here all night with you.'"

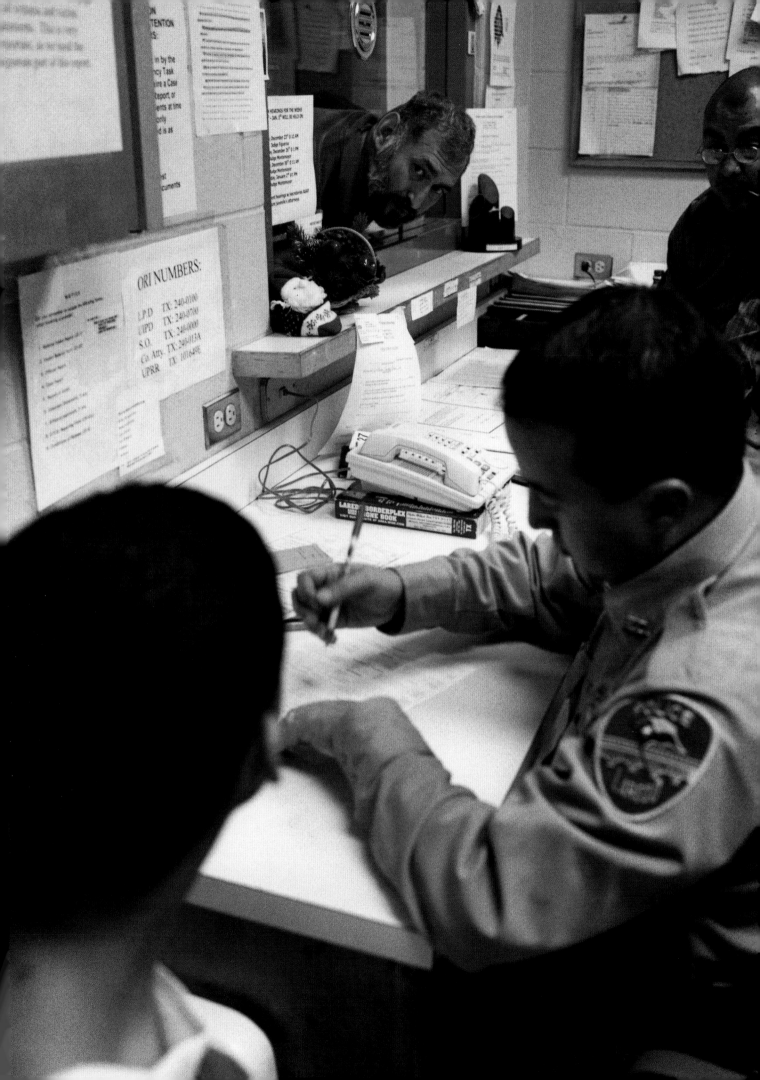

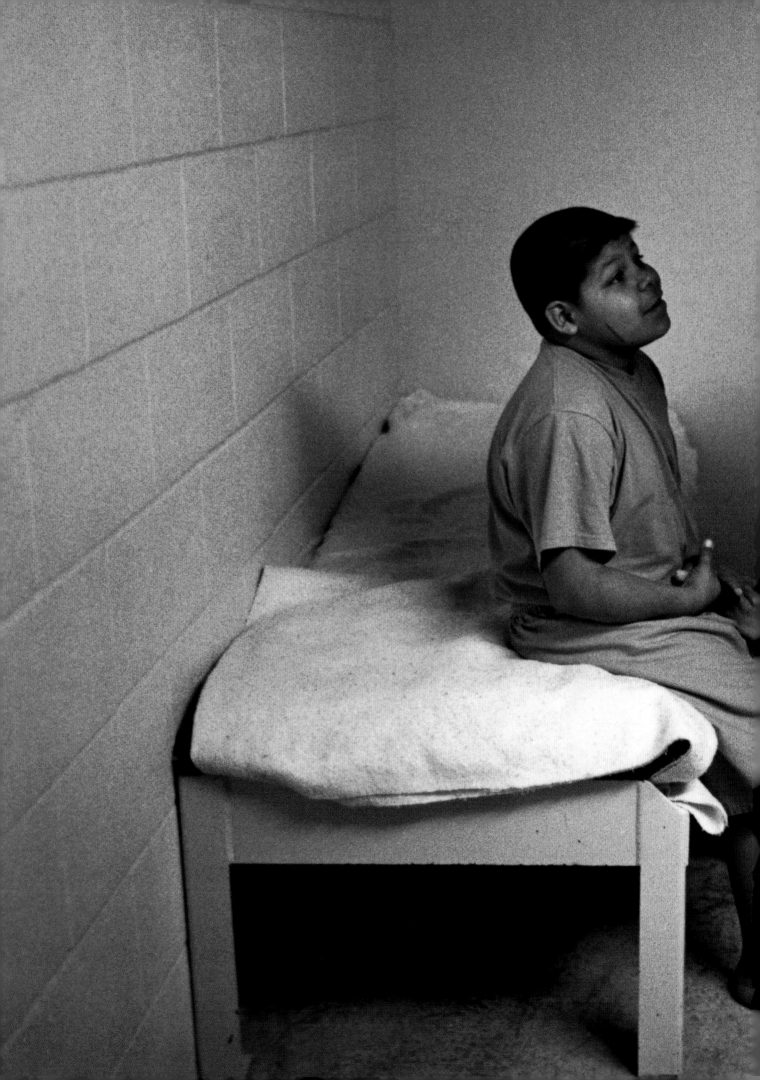

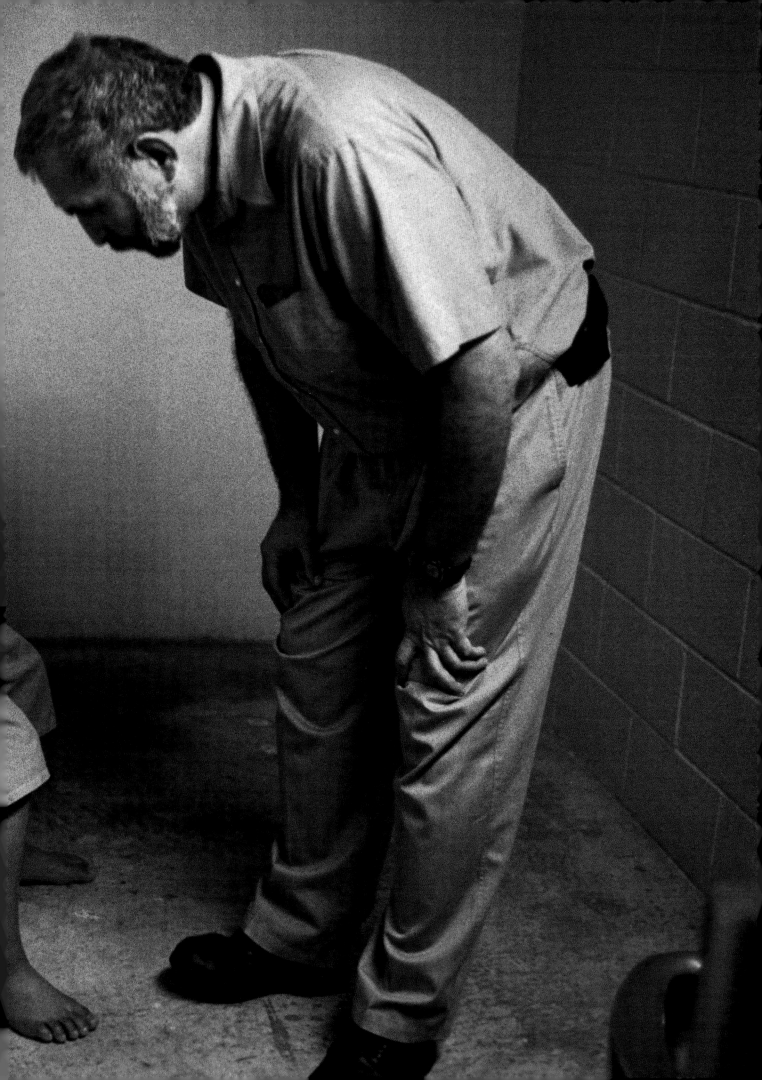

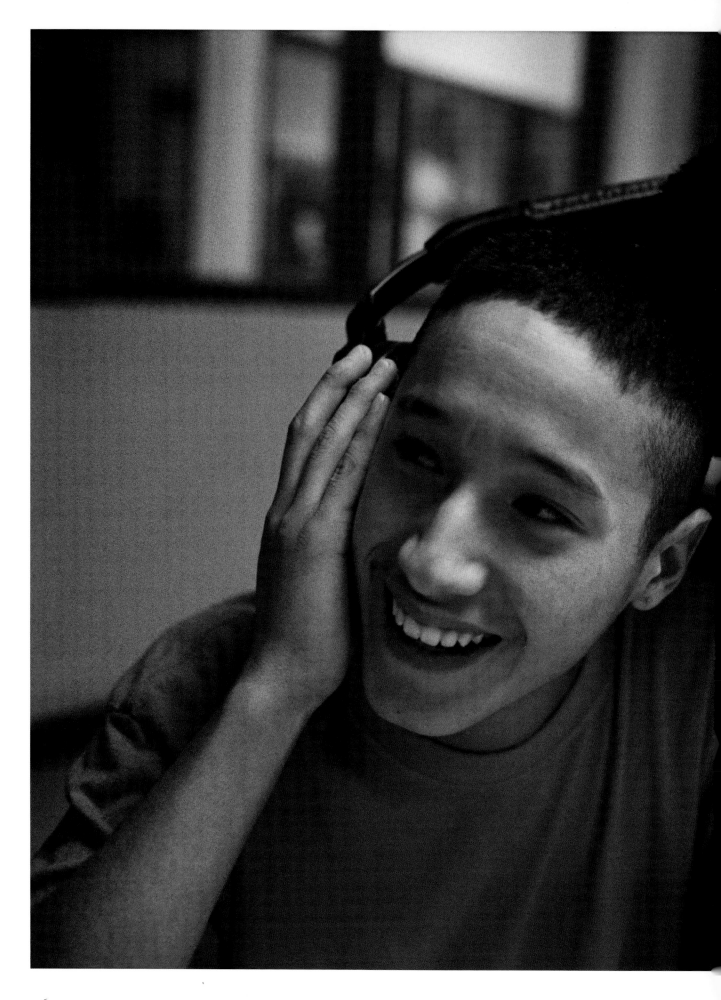

NO PLACE FOR CHILDREN

The twins

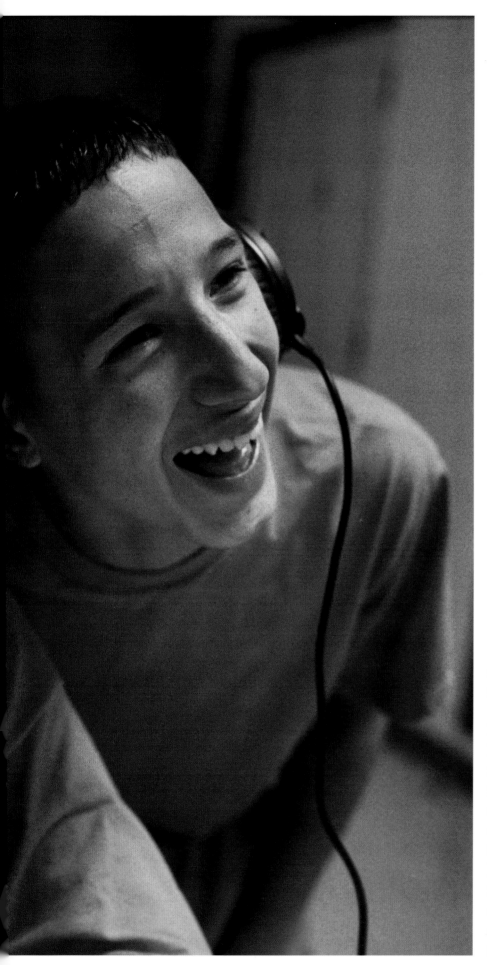

"The saddest thing that ever happened to me was when they took my father away."

Fourteen-year-old twins Jose Luis and Jose Eduardo lost their dad when he was arrested for selling drugs. They haven't seen him since he was sent to an out-of-town jail. That's when the trouble began. The brothers have made more than a dozen trips to Juvenile since first being sent for jumping one of their classmates in the elementary school lunchroom.

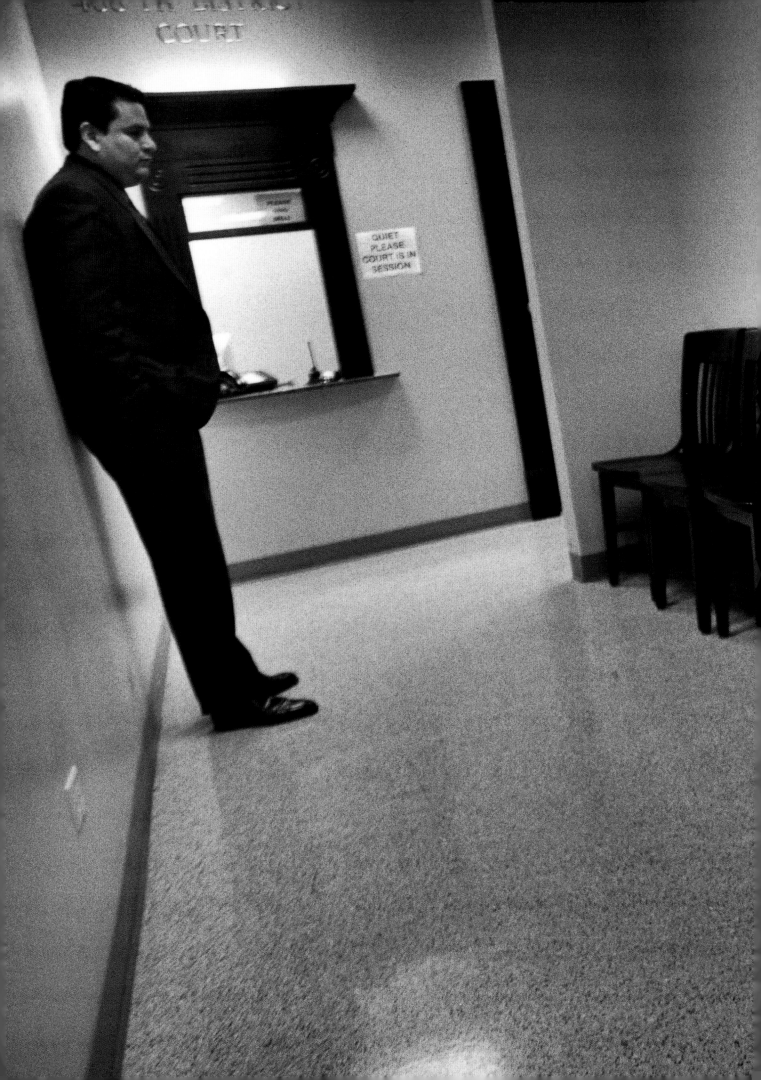

At the courthouse with Mom: "I feel depressed 'cause of what I did to my mom. She was suffering for me, and she is suffering right now."

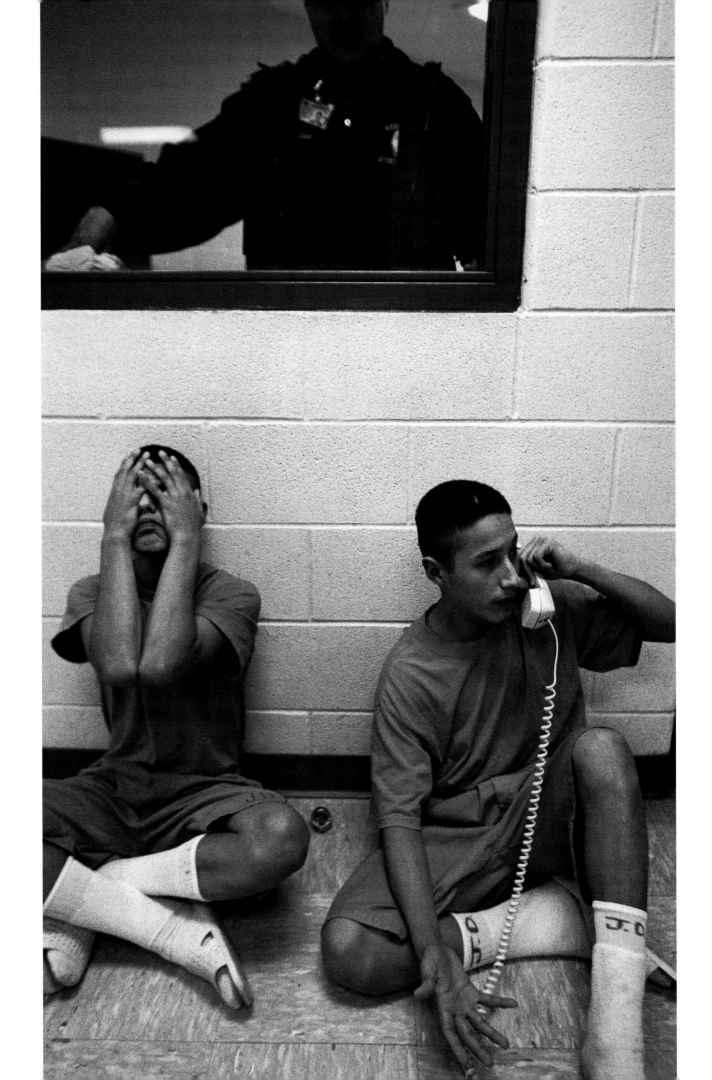

The deck is stacked against them.

The twins are living a tired cliché. First, they lost their dad. Now, they're losing their battle to break what's become an endless cycle of crime and incarceration.

After losing their dad to prison, the brothers filled the void with a steady string of assaults, drug use, and auto theft. Dad had been no role model, but at least he had earned his sons' respect.

"When my dad was around we used to not do anything bad 'cause he would talk to us and everything," says Jose Luis. "But when they took him to jail we started to do all this stuff. It's 'cause my mom doesn't do anything to us. She doesn't like to hit us. My dad would spank us, or scream at us, and tell us not to do bad things. My mom tells us, too, but, ah, we blow her off."

The brothers' story sounds familiar to Case Management Director Pat Campos:

"You have to work with the entire family or it's not gonna work. We'll send a kid out of town to a rehab, and the kid will do excellently. But once they come back home, if we have not worked with that family, it made no sense to send him out of town. The family is the same way they were when that child left. In order to help a child you have to help the entire family. And we have a lot of very young parents. They don't have any idea how to take care of a child."

Neither does the justice system, at least in the twins' case. One of the brothers describes his trips to court:

"I was always telling the judge I needed help on drugs. They wouldn't listen to me. My PO doesn't want to risk it. He says that I'm going to run away from there. I've never been to rehab even once."

But Jose Luis finds a sad silver lining to his travails:

"It sucks to be here, but it's keeping me safer than out there on the streets. 'Cause out there on the streets, I was doing all these bad things and in here I'm safe. Out there I can get shot and shit. . . ."

"I've already had it with this. When I come out I wanna change already. I don't wanna be the same guy," says Jose Luis, who is starting his fourth month in detention.

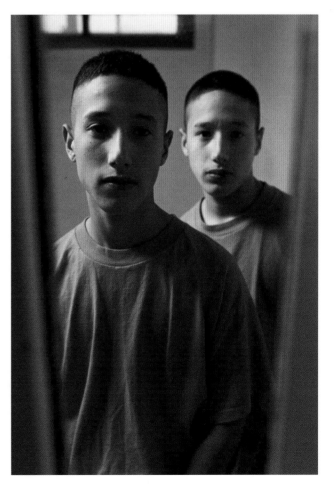

Holkan

"I don't know if I really did it or my friend did it. I don't know which bullet got to his head."

Police think that it was a bullet from 16-year-old Holkan's 9-millimeter pistol that killed another 16-year-old that Friday night. Both Holkan and his victim were members of gangs, and the local newspaper wrote that the crime "epitomizes the current gang problem in Laredo." But long before his story made headlines, Holkan's life personified the insidious effects of family breakdown and untreated drug addiction. A kid described by former teachers as "happy" and "cooperative" didn't become a poster child for gang crime overnight.

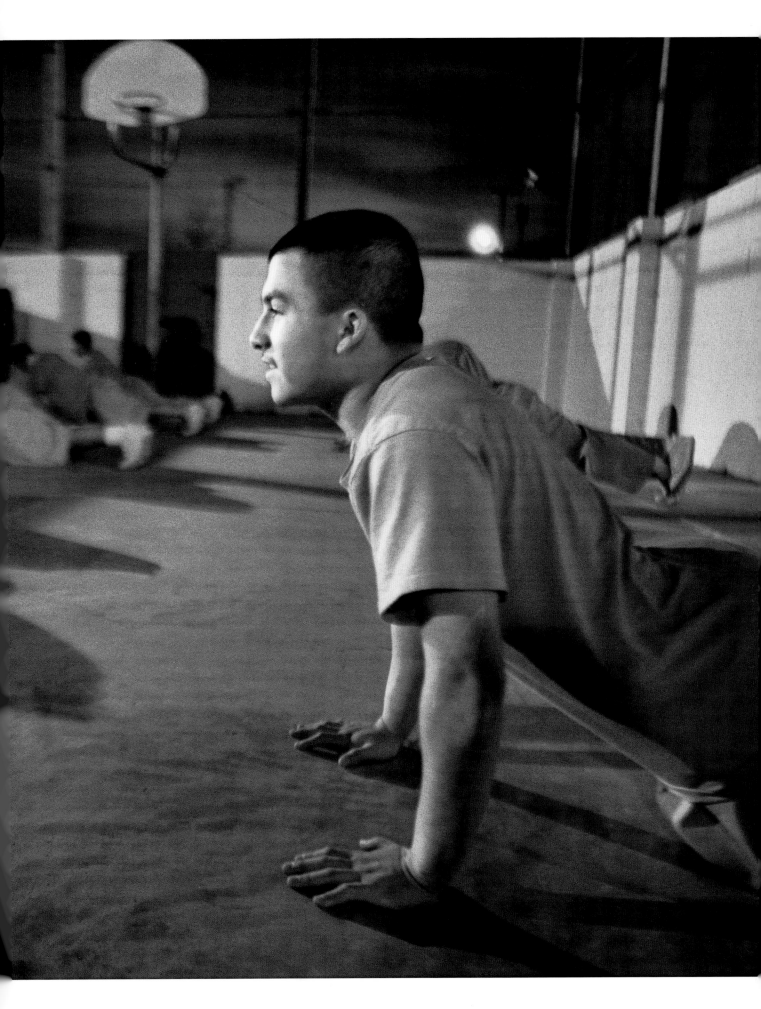

He wants a second chance.

Sometimes seeing your fate is not enough to save you from falling victim to it. In his older brother Juan, who died in a gang fight one year before Holkan's arrest, he could clearly see the potential perils of his surroundings. "He was always in trouble," Holkan remembers. "But he was in Mexico. You wouldn't like to be in jail over there. I would go and visit my brother and, every time, he was always beat up. My mom would always cry."

By then, Holkan was used to seeing his mom cry. He doesn't remember his dad, who left the family when Holkan was five months old and hasn't been heard from since. His mom, who only made it through the fourth grade, raised the family alone, juggling multiple jobs. At the time of Holkan's crime, she was a cashier at a fast-food restaurant and a janitor at the local mall. She tried to do the best for her youngest son, who suffered from learning disabilities and took special education classes. But he knew the streets and he had a plan for getting away.

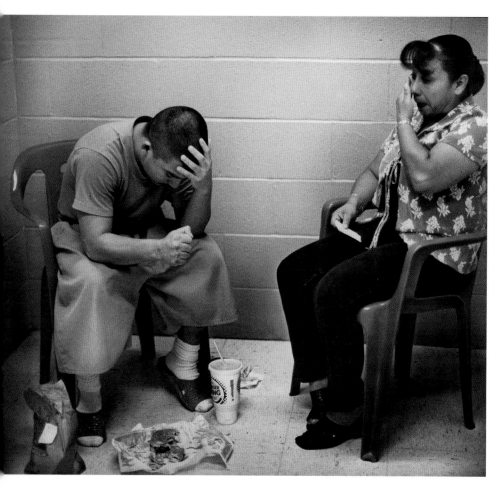

Holkan, who has a tattoo dedicated to his dead brother, with his mom in Juvenile: "I hate her coming here and visiting me. Every time she comes she always leaves here crying. I hate it. I hate it bad."

Holkan knew he had to leave. "I dropped out of school 'cause I wanted to go to a military school in Galveston. I knew if I stayed down here in Laredo, I would be ending up in prison."

He didn't get away in time. Instead, he ended up on Poza Rica Drive that Friday night.

"They were running behind me and I couldn't do anything except shoot. . . . Me and my friend, we both did. The morning after, my mom told me that there was this guy dead and that they were looking for me. I didn't feel right, so I went down to the police station and I turned myself in."

Holkan, who had never been to Juvenile before, was now charged with murder. The prediction that sent him looking to escape his gang-dominated world had come true.

"Everything is all my fault 'cause of the people I hanged around with."

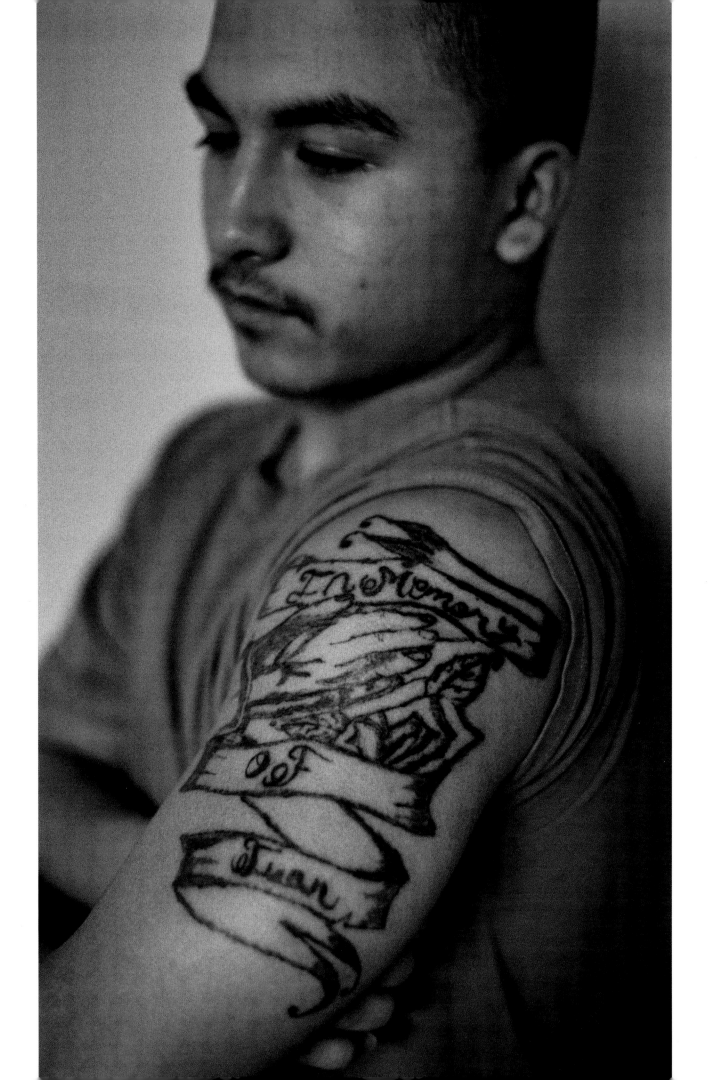

Rene

*"I have seen all types of drugs.
All types of drugs."*

Rene, 15, has transported drugs, too. But mainly
he has used them—marijuana, coke, heroin, and
pills. It's the pills, *rochas* (Rohypnol tablets), that
triggered the latest fight with his parents. Rene
swung for his mom but ended up giving his dad a
black eye. With nowhere else to detox, he ended
up in Juvenile.

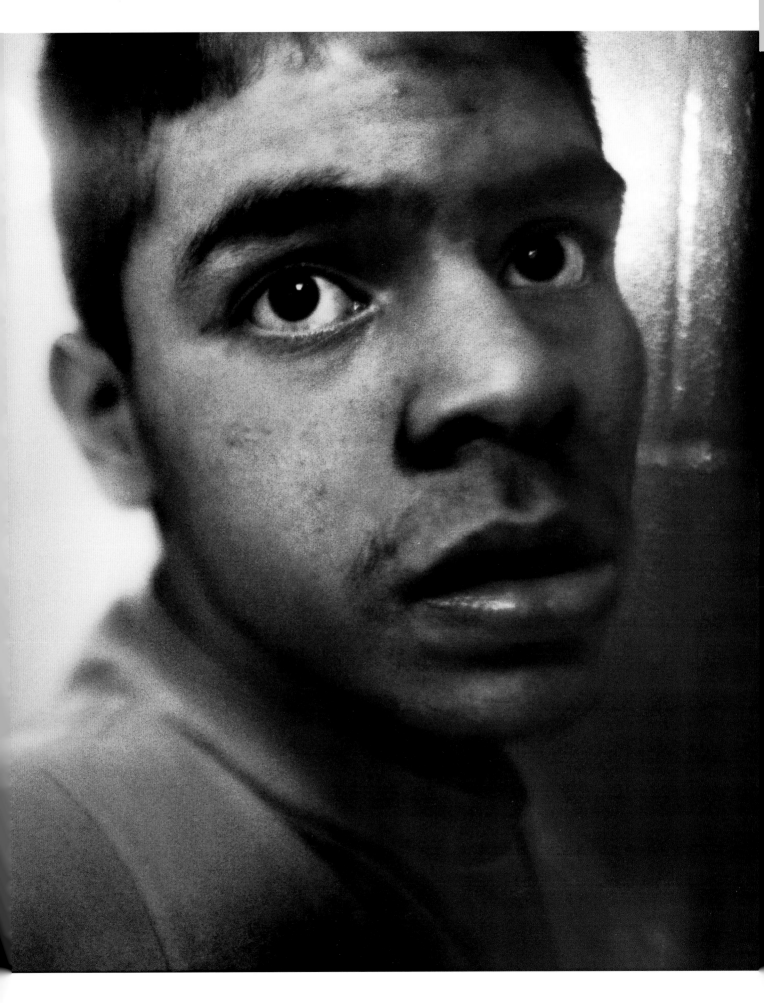

The nightmare that is detox

The first three days of withdrawal from drugs are a living nightmare: The user experiences deep anxiety and physical and emotional pain. In a detox center, he would undergo detoxification with the full support of a medical staff. There would be medication. His vital signs would be checked every 20 minutes. He would have a bed and be constantly hydrated. But in juvenile detention there is only an empty cell. His body writhes on a concrete floor as guards stand by, in case he should try to hurt himself. It is a cold and traumatic ordeal.

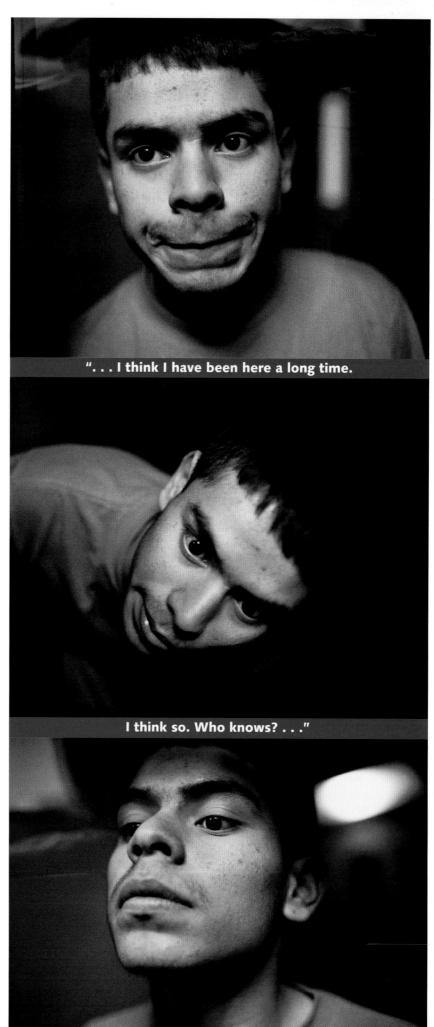

". . . I think I have been here a long time.

I think so. Who knows? . . ."

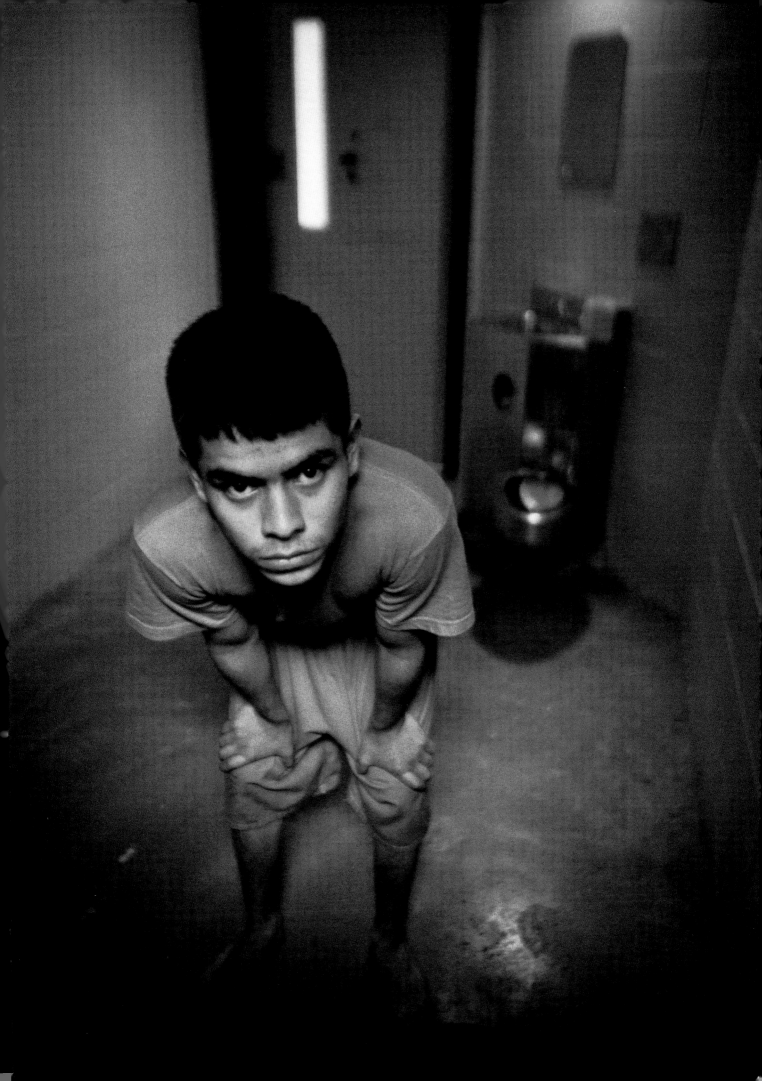

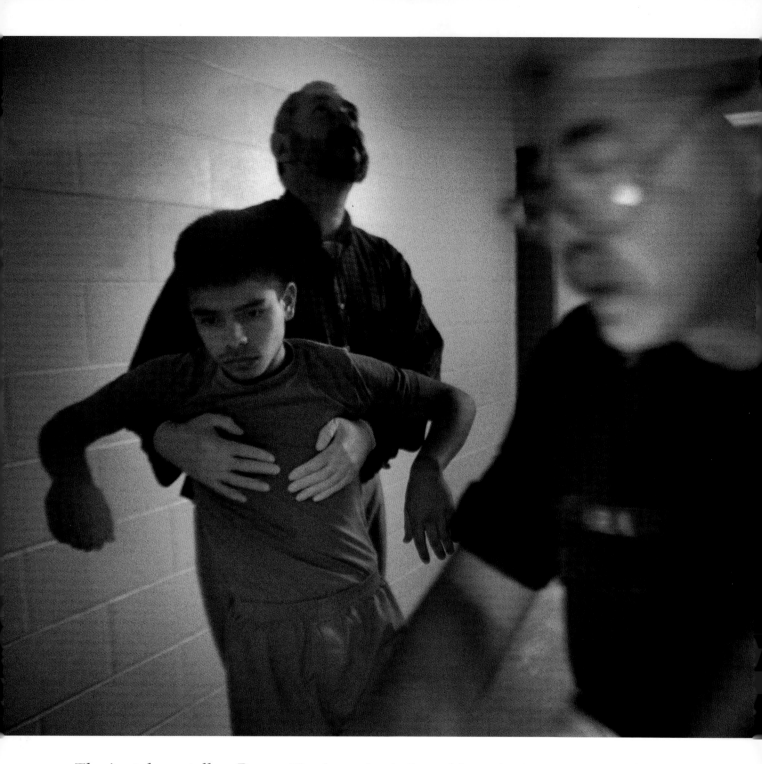

They've taken a toll on Rene. The drugs, that is. Lots of drugs, beginning at age 13. Doctors suspect that he has brain damage, probably because of drug use. So, his parents turned to an alphabet soup's worth of agencies for help. His mother's experience:

"I went all over the place and they wouldn't help me anywhere. I went to RAICES, to STACADA. They are more or less helping him at CAPS. We would be sent from doctor to doctor and then sent to run around looking for this or that paper. They would tell us that the

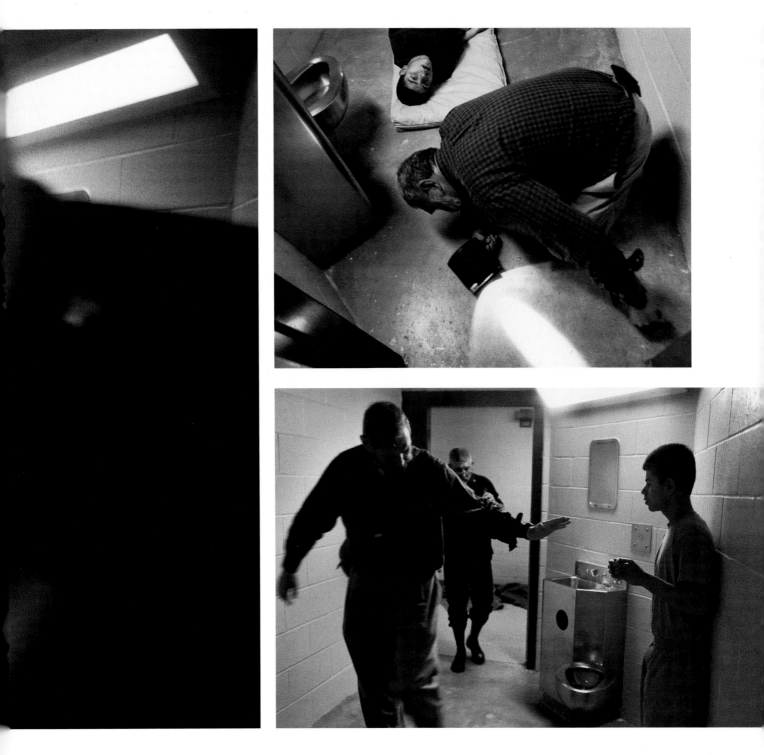

rehabs here were voluntary. They said they couldn't make themselves responsible if he took off."

So Rene's family turned to Juvenile to keep him away from drug-using friends. "It's not that we want to have him locked up," Rene's father says. "It's just so that he will see."

Now Rene is a familiar face at Juvenile. But don't ask him for details. The drugs have taken their toll.

Detention officer Leo De La Garza carries Rene, who is high on pills, into a cell. Later, De La Garza searched for a sharp object, which he feared Rene might use to kill himself.

Ivan

"I'm 16 years old and I have nothing to be proud of. I have all this pride inside of me, yet I look back and I have nothing to be proud of."

That was back then, back when drugs and crime held Ivan tight in their grip. Back then, he made 15 trips in and out of Juvenile, each time falling further behind in school. Back then, Ivan had written himself off. "What would help me? If I knew, I probably would have changed by now." End of story?

Not so fast.

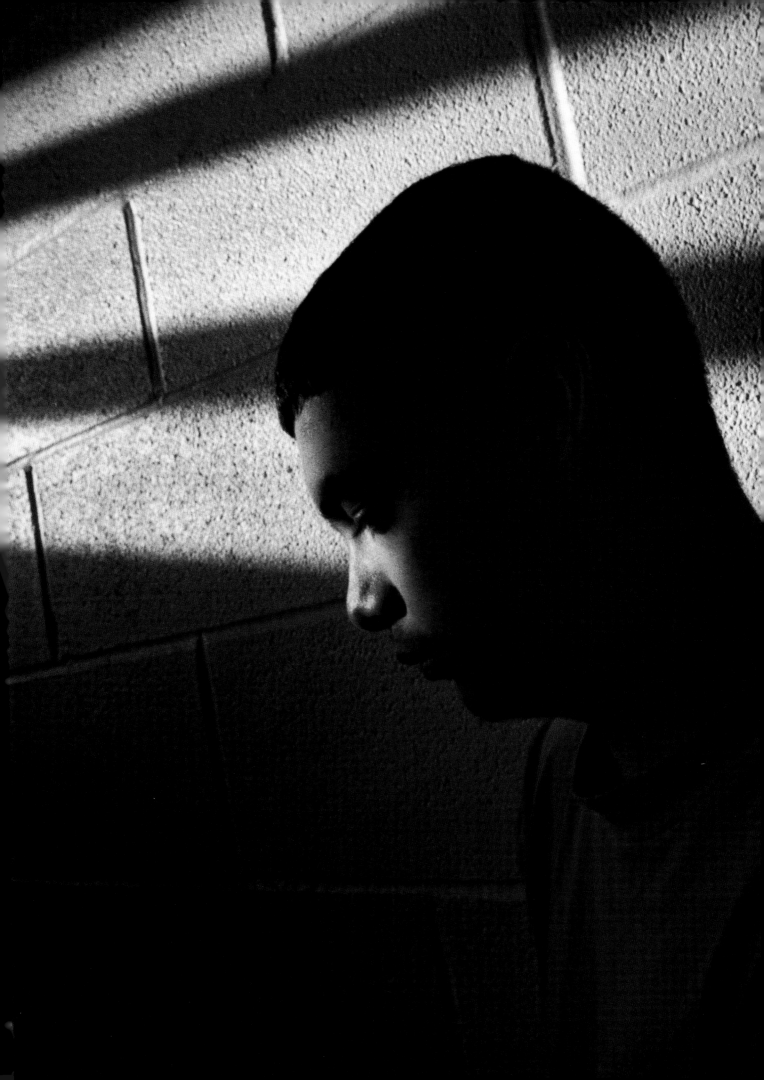

He learned a lot from his mother.

As an eight-year-old, Ivan learned that crime could pay. And he learned that it would be "stupid" to let doing the right thing get in the way of making a quick buck. Now, he's paying for his upbringing.

"I had stolen about two hundred bucks in third grade from some kindergartners' field trip money. I kind of felt guilty, so I told my mom, 'Well look, Mom, here it is. Should I go turn it in?' She said, 'Naw, don't be stupid. Come on, let's go.' So she took me, and I kept the two hundred. Yeah, I've stolen a lot of stuff, but my mom's helped me sell it all off. She'll take it across to Mexico and she'll sell it for me. And she only takes like 10 percent of whatever we make."

At the same time, Ivan filled a void at home.

"My father had a stroke so the left side of his body is completely numb, so I had to take care of him once my mother left us. Actually, I haven't seen my mother for about seven, eight months now. She left and took my little sister with her, but my little sister actually wised up and said 'Hey, I can have a better life than my father and my brother.'"

The repeated stays in Juvenile have set Ivan back, and he knows it. But he's not solely to blame.

"I lost about two years of high school just being locked up, in and out. I was never allowed to make up my work, so I lost a lot of credit. All they'd do here is give you a little handout and have you copy it. There's one teacher, and he gives you the same work whether you're 10 or 16."

Ivan's story looked sadly familiar—until June 17, 2002. That Monday, in his cell in Juvenile, Ivan says he "finally grew up."

"I looked at myself and I said, 'What the hell am I doing here? Why am I so stupid? Why can't I learn? I keep committing the same mistakes again and again. So I made up my mind and said, 'Fuck it. Wherever they send me, if I get out I'm going to change.'"

And change Ivan did. He got his GED and then a new family: "From the minute I met my beautiful girlfriend I cut everybody loose. I didn't go out. I didn't go to parties. I've been sober for a year—no drinking, no drugs. I don't have the same friends that I used to. The next thing you know, my girlfriend's pregnant and I have a beautiful baby now."

"They say there's only three ways to leave drugs: You either die, you work the program, or you find God."

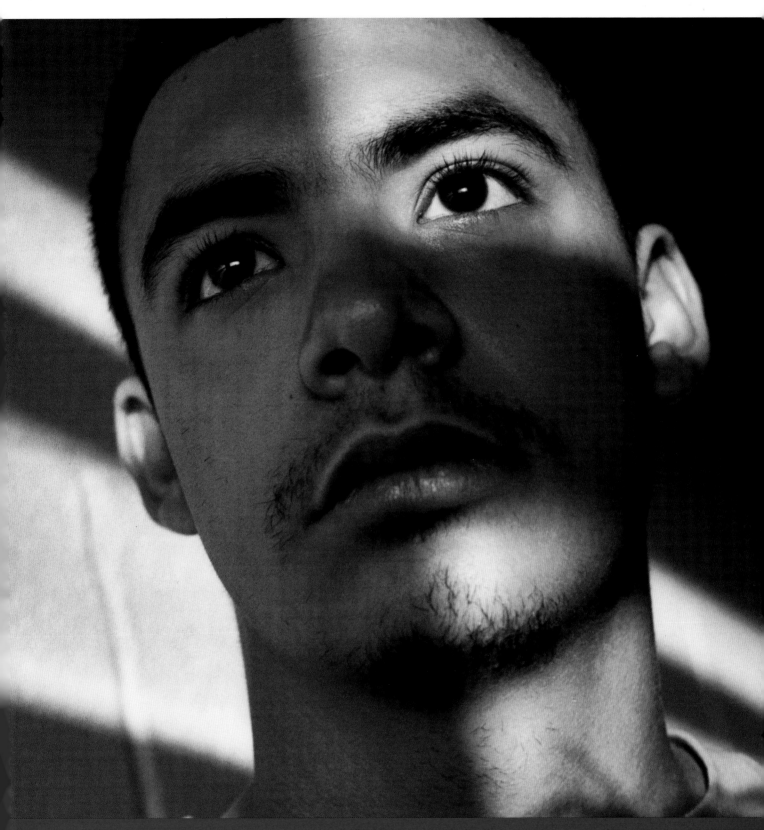

"Right now I'm just worried about tomorrow. It's kind of naive to think that you'll be around for tomorrow. And I've been thinking about that a lot because of my friend that just died. It's not like in the movies when you see a casket get lowered into the ground. It's not at all like the movies. That shit's real."

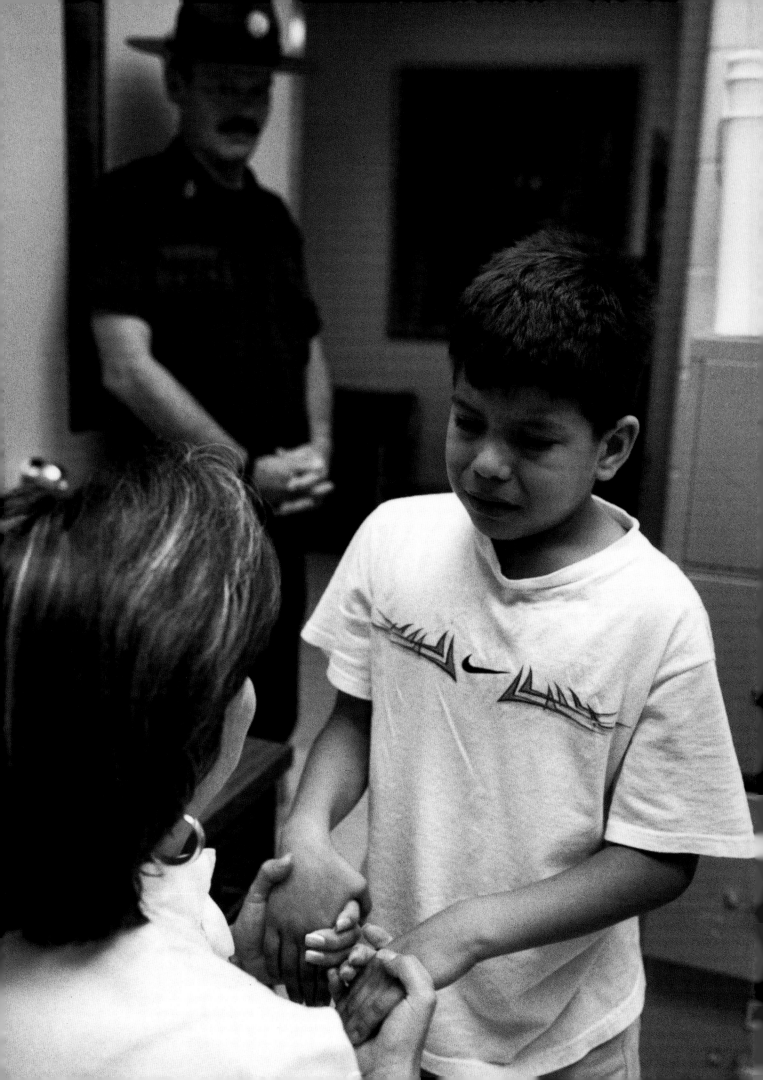

BART LUBOW
Director, Program for High Risk Youth
The Annie E. Casey Foundation

AFTERWORD

Steve Liss's rare and poignant photographs of kids in a secure juvenile detention center accurately capture the drama, angst, and tragedy that are the emotional infrastructure of far too many of these institutions. When we consider that there are 600,000 annual admissions to these juvenile jails, concerns about the experiences depicted here should take on great urgency.

At best, and in contrast to common wisdom, juvenile detention centers are generally ineffective in making the public safer; at worst, they are outright harmful. In fact, research now shows that such confinement is a stronger predictor of recidivism than either gang involvement or

weapons possession. Secure confinement, more-over, frequently fractures the already tenuous connections of most delinquents to schools, which ultimately reduces the productivity of these children as workers for years to come. In other words, America's detention centers can increasingly be viewed as schools for crime.

As a society, why do we tolerate a system that exposes kids to these conditions and produces these dysfunctional consequences? Perhaps it is because most of these children are kids of color or come from impoverished backgrounds. Many practitioners and commentators believe that these circumstances would not prevail if the children in detention were not overwhelmingly African American, Latino, or poor.

As disturbing as the realities depicted in Liss's pictures are, they become even more upsetting when we realize that they are largely avoidable. Tens of thousands of children each year are detained *inappropriately*—for reasons inconsistent with detention's recognized purposes—*or unnecessarily*—because alternatives are unavailable. More than half of youths locked up in detention centers are confined for status offenses (like running away from home or truancy), technical violations of probation, or nonviolent offenses. This suggests that it is largely the decisions and behaviors of the adults who fund and oversee the juvenile justice system, not the behavior of these underserved children, that must be changed if we truly wish to improve the odds of children growing out of delinquency and becoming productive adults.

We now have extensive proof that these changes are possible. In a growing number of states and counties, well-documented juvenile detention reform strategies—tested through a decade-long demonstration project known as the Juvenile Detention Alternatives Initiative (JDAI)—are being implemented, and are substantially and safely reducing reliance on secure detention. Cook County (Chicago), Illinois, Multnomah County (Portland), Oregon, and Santa Cruz County, California, serve as the prototypes for this growing reform movement. In Cook County, detention use was reduced by 37 percent,

while juvenile arrests for violent offenses declined by 54 percent. In Multnomah and Santa Cruz, the corresponding outcomes were 66 percent and 43 percent decreases in detention, and 45 percent and 38 percent decreases in juvenile crime. Multnomah County, furthermore, demonstrated that it was possible to even the odds for arrested youth being detained, regardless of race or ethnicity. These results were major breakthroughs and are now being replicated in many places.

And what about those truly dangerous youth

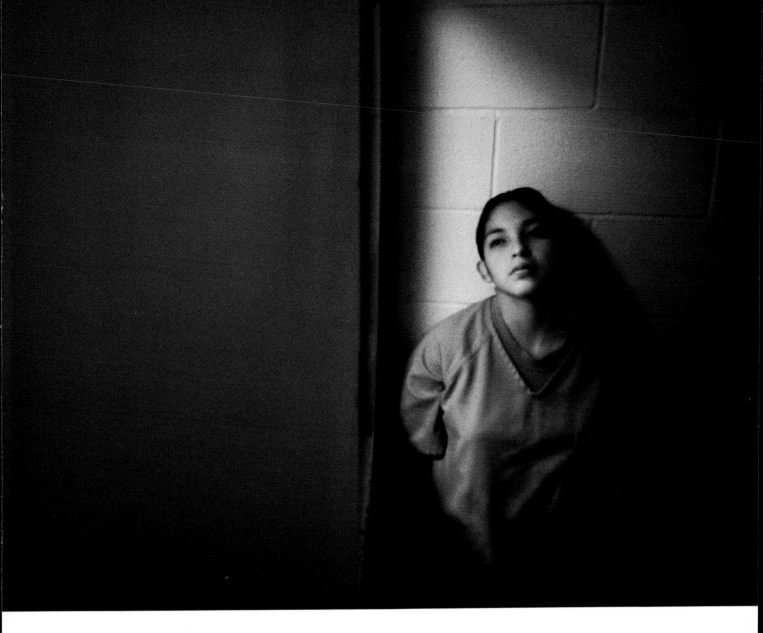

who do require secure detention? The impact of detention reform on facility populations has meant better conditions of confinement, including more extensive programs and remediation; fewer health and safety risks; and improved opportunities for meaningful interaction with less-stressed, better-trained staff.

This growing juvenile detention reform movement is transforming the use and environments of the destructive institutions so powerfully presented in this book. This movement is also cause for broader optimism: if adult thinking and action can be changed sufficiently to break our addiction to caging kids who frustrate or anger us, perhaps the nation's juvenile justice system could actually do some good for the children who are its wards. Then we might not be confronted by the horrible paradox captured in this book's title: that juvenile detention centers are, indeed, no place for children.

To learn more about JDAI, please visit **www.aecf.org** and click on "initiatives."

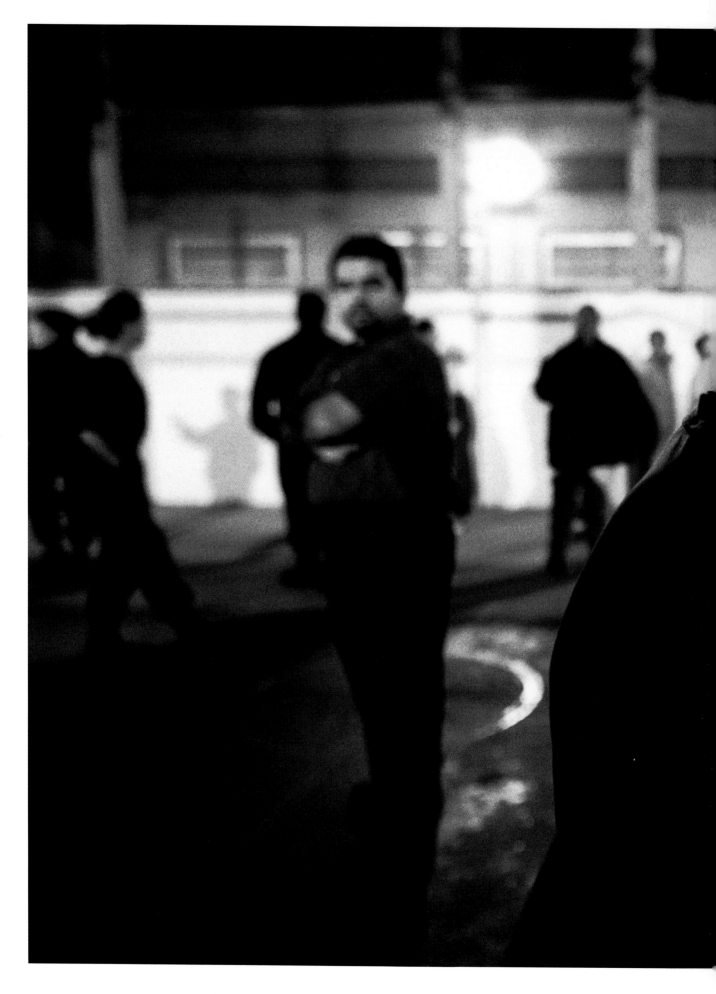

NO PLACE FOR CHILDREN

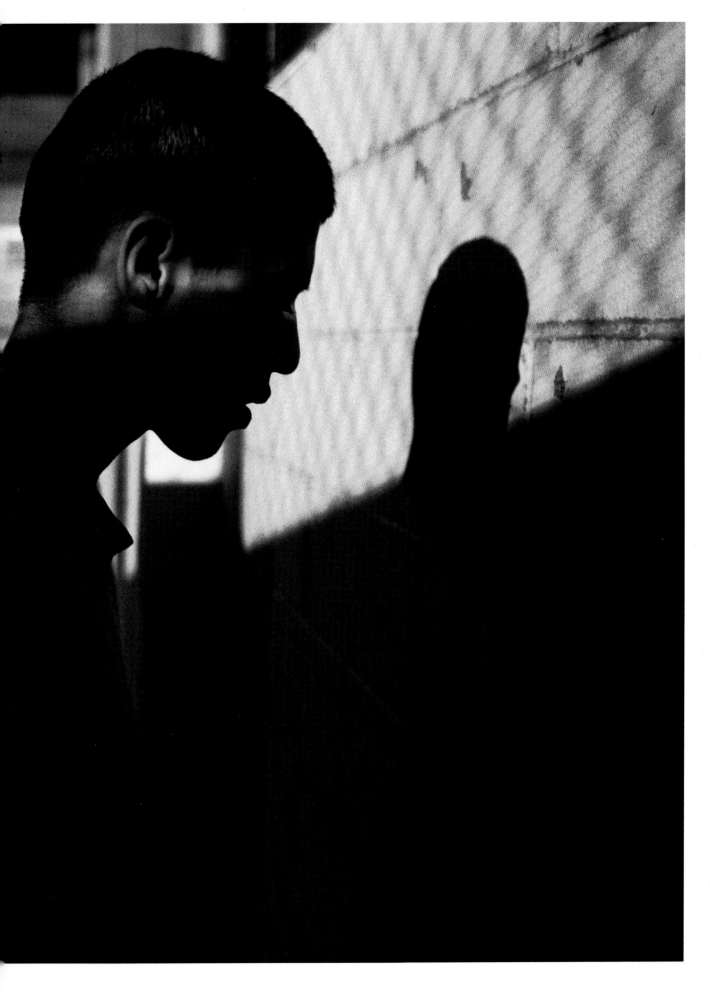

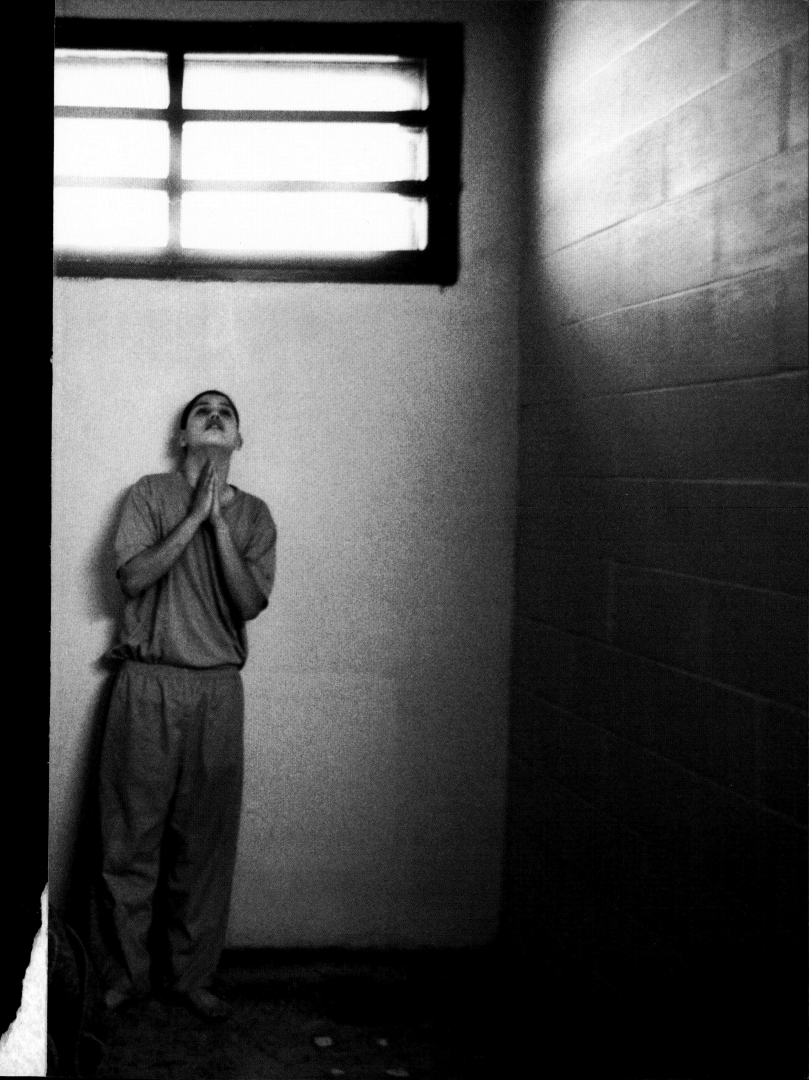